IMAGES
of America
MARK TWAIN'S HARTFORD

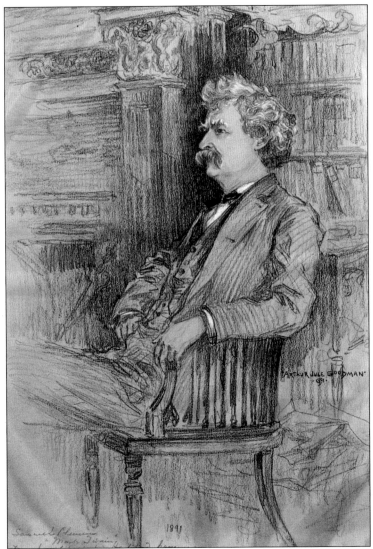

Samuel L. Clemens, known as Mark Twain, sits next to the library fireplace in his Hartford home in 1891 for a sketch by magazine artist Arthur Jule Goodman as the family's departure from the house approached. The failure of the author's investment in a typesetting machine, some poor decisions in a publishing venture he headed, and a nationwide economic slump contributed to their leave-taking, which they considered only temporary. But the author had spent nearly two decades of his most productive years in this house. And the time that he and Livy Clemens spent there with their daughters provided warm family memories to comfort them in succeeding years, which were to grow increasingly difficult. The house—with its ornate oaken chimneypiece, part of which can be seen here—is now preserved as a museum. (Courtesy of the Mark Twain House & Museum.)

ON THE COVER: The members of the Clemens family, with their dog Flash, have taken their places on the porch of their home in Hartford, Connecticut, for a portrait in 1885. From left to right are Olivia Clemens, always known as "Livy"; Clara Clemens, who turned 11 that year; Jean, about five; Samuel Clemens; and Susy, about 13. (Courtesy of the Mark Twain Papers and Project, Berkeley.)

IMAGES
of America

MARK TWAIN'S HARTFORD

Steve Courtney; foreword by Cindy Lovell
of the Mark Twain House & Museum

ARCADIA
PUBLISHING

Copyright © 2016 by Steve Courtney
ISBN 978-1-4671-1558-2

Published by Arcadia Publishing
Charleston, South Carolina

Printed in the United States of America

Library of Congress Control Number: 2015947868

For all general information, please contact Arcadia Publishing:
Telephone 843-853-2070
Fax 843-853-0044
E-mail sales@arcadiapublishing.com
For customer service and orders:
Toll-Free 1-888-313-2665

Visit us on the Internet at www.arcadiapublishing.com

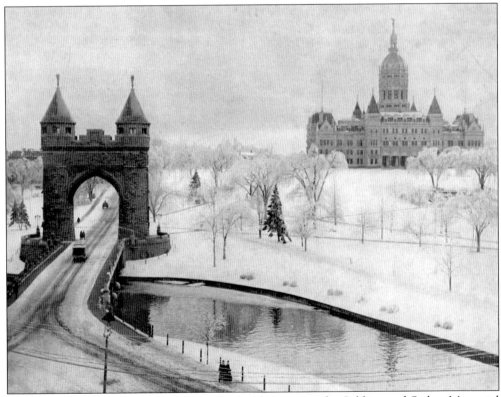

In a winter view, the Connecticut State Capitol looms over the Soldiers and Sailors Memorial Arch in Hartford, Connecticut, in Clemens's time. Hartford was not only the seat of Connecticut government—it was also a wealthy place. One newspaper editor claimed, "Relative to the number of its inhabitants, it is the richest city in the United States." He was stretching a point, but the boast was believable. (Courtesy of the Mark Twain House & Museum.)

CONTENTS

FOREWORD

Mark Twain remains Hartford's most famous resident, and Connecticut's capital city proudly and rightfully claims him as its own, just as Hannibal, Missouri, can and does. In an 1881 speech, Samuel L. Clemens declared, "I am a border ruffian from the State of Missouri. I am a Connecticut Yankee by adoption. In me you have Missouri morals, Connecticut culture; this, gentlemen, is the combination which makes the perfect man."

This "perfect man" determined that Hartford was the perfect city—not simply to call home, for he had lived an itinerant's life, always on the move, transient by nature, but the city where he and his wife would build the house in which to raise their children, the house that immediately became home and the place where he would live the longest. The mansion at 351 Farmington Avenue in Hartford's Nook Farm neighborhood would be named "one of the ten best historic homes in the world" by *National Geographic* in 2012, but to Sam and his wife, Olivia, it was so much more than a Gilded Age architectural treasure. In a letter to his friend and Hartford neighbor, Joe Twichell, Clemens wrote: "To us our house was not unsentient matter—it had a heart & a soul & eyes to see us with, & approvals & solicitudes & deep sympathies; it was of us, & we were in its confidence, & lived in its grace & in the peace of its benediction. We never came home from an absence that its face did not light up & speak out its eloquent welcome—& we could not enter it unmoved."

Like all cities, Hartford has changed since Clemens's time, but many of the historical features Steve Courtney describes in *Mark Twain's Hartford* stand conspicuously in a modern Hartford. These include the Clemens mansion, which then housed the family, servants, countless visitors, and a menagerie of pets and farm animals and today welcomes visitors from every corner of the globe. I invite you to come visit Mark Twain's Hartford—today.

—Dr. Cindy Lovell, Executive Director
The Mark Twain House & Museum

ACKNOWLEDGMENTS

Many decades of work by dedicated staff, volunteers, lovers of Mark Twain, donors, and Samuel Clemens's own family members—notably his daughter Clara—contributed to the pictorial collections from which most of this work has been drawn and also to the collection and preservation of an important collection of artifacts at the Mark Twain House & Museum in Hartford.

Of course, the main artifact of all there is the Clemenses' Hartford house itself. The present-day and recent staff members who have contributed to the project in additional ways include executive director Cindy Lovell, chief curator Tracy Brindle, assistant curator Mallory Howard, and immediate past chief curator Patricia Philippon. Intern Rachel Adams was of invaluable help. At the Mark Twain Papers and Project at the Bancroft Library, University of California, Berkeley, I want to thank in particular general editor and curator Robert H. Hirst and associate editor Victor Fischer. Austin, Texas, bookseller Kevin Mac Donnell also must be thanked for use of an item from his extraordinary Twain collection. Dr. Kerry A. Driscoll of the University of St. Joseph, West Hartford, Connecticut, has been as always an important contributor with ideas and conversation. Elisabeth Petry provided an essential photograph. My title manager at Arcadia, Sarah Gottlieb, was crucial to the smooth production of this work.

Finally, Lisa Bower Courtney, my beloved wife, has given up scads of time during the summer of my work compiling this book, which could have been more fun and companionable if I had not been doing it. She is a treasure to me in every way.

Except where otherwise noted, images in this book are courtesy of the archival holdings of the Mark Twain House & Museum in Hartford, Connecticut.

AN AUTHOR
AND HIS CITY

It comes as a surprise to many that when Mark Twain wrote his famous tales of old times along the Mississippi River—of Huck and Tom, steamboats, slave hunters, and snags—he was, as he described himself, "an immovable fixture among the other rocks of New England."

It was a business trip that first brought Samuel Langhorne Clemens to Hartford, Connecticut, in January 1868. The writer's pen name was already well known from his time in San Francisco, California, when his story "Jim Smiley and His Jumping Frog" was published in a New York journal, but now, at 32 years old, he had seen many more cities than these. He had cajoled and convinced his newspaper, the *Alta California*, to pay for him to take an ocean trip to Europe and the Holy Land, a June-to-October 1867 pleasure excursion on the former Union blockade ship *Quaker City*.

Clemens sent back dispatches full of vivid travel writing, incident, and wild humor—he was, after all, billed as the "Wild Humorist of the Western Slope." He had seen Paris, Rome, Athens by moonlight, Constantinople, Jerusalem, and Alexandria. But when he got to Hartford that January, he wrote a description for the *Alta*: "Of all the beautiful towns it has been my fortune to see this is the chief . . . You do not know what beauty is if you have not been here." The words still strike wonder in those who know Hartford, which today faces the challenges of postindustrial urbanism, stricken by blight and tangled highways.

In 1868, Hartford was a prosperous place. Clemens was in the city to meet Elisha Bliss, the publisher with whom he would contract to turn his *Alta* travel dispatches into a book. Hartford interested him, as many places interested him in his voracious way. He could no more stop himself from note-taking on his surroundings wherever he was and turning what he saw into pictorial prose than he could stop breathing. "They have the broadest, straightest streets in Hartford that ever led a sinner to destruction," he wrote, "and the dwelling houses are the amplest in size, and the shapeliest, and have the most capacious ornamental grounds about them . . . This is the centre of Connecticut wealth. Hartford dollars have a place in half the great moneyed enterprises in the Union."

What was this city that outrivaled Paris in his estimation? Settled by a small group of breakaway Puritans from Massachusetts in 1636, it had grown into a port on the wide, navigable Connecticut River. In 18th-century coffeehouses, the town burghers put together plans to insure the risky voyages that took New England salt beef and cod to the West Indies to feed slaves who produced sugar and rum for New England and Europe. The slaves were not enriched, but the Hartford burghers were. The city manufactured clothing and guns for Washington's army and did the same for Lincoln's. By 1868, Hartford was humming with activity, even with the vast wartime market for destruction curtailed. About 40,000 souls populated the city when Clemens arrived in town.

When Clemens first came to Hartford to see Bliss, he stayed with a minister's sister, Isabella Beecher Hooker, and her husband, John. The couple were founders of a small community on the outskirts of Hartford called Nook Farm. Clemens was charmed by the leafy surroundings, the views down long, straight Farmington Avenue, distant vistas of the city to the east, and the blue misty hills to the west.

Clemens was falling in love with the city. He already had fallen in love with a young woman from upstate Elmira, New York, Olivia "Livy" Langdon, whose miniature portrait he had seen displayed by her brother Charles, an 18-year-old fellow passenger on the *Quaker City* voyage. She was 21. He had met her in New York the previous winter, and she had Hartford connections, too. Her prosperous family's Elmira pastor was Thomas K. Beecher, brother of Isabella Hooker, Henry Ward Beecher, and Nook Farm's most famous resident, Harriet Beecher Stowe. The Hookers' daughter Alice was a close friend of Livy's.

Hartford's draw was strong. Clemens made friends among the intelligentsia of the city as he worked on the book with Bliss. His meeting with the Yale-educated minister Joseph Twichell was typical—they were introduced at a social function, started a conversation, and set a dinner date. On the appointed evening, Clemens sat with Twichell, the minister's wife, Harmony, and young son, Edward. He told them about Livy. At 9:30 p.m., Clemens rose to leave, his arms full of books Twichell wanted him to borrow, and the two men walked to the door. But Twichell "would have his talk out," Clemens wrote, and the pair stood at that door talking for an hour and a half more.

In a letter he later wrote to a relative thinking of moving from Iowa to Hartford, Clemens says, "Making friends in Yankee land is a slow, slow business, but they are friends worth having when they are made." On these early business trips—as the best-selling book of his life, *The Innocents Abroad: The New Pilgrim's Progress*, took form—he made friends more quickly, and they were indeed worth having.

These convivial attractions brought the now-married Clemenses to Hartford to stay three years later. They leased the Hookers' home and planned to build a house nearby. When three years after that—in 1874—it was completed, it was a marvel, a symphony of decorated brick, Elizabethan chimneys, jigsaw-cut butterflies, wildly varying balconies, and a vast porch for the kind of relaxed conversation and easy companionship he had found in this starchy New England town.

Throughout the two decades that followed, he and Livy raised a family in the house. Samuel Clemens, as Mark Twain, rode on the fame of *The Innocents Abroad* and compounded it with *Roughing It, The Gilded Age, The Adventures of Tom Sawyer, A Tramp Abroad, The Prince and the Pauper, Life on the Mississippi, Adventures of Huckleberry Finn*, and *A Connecticut Yankee in King Arthur's Court* as well as dozens of short stories, sketches, and funny speeches. His life among the editors, lawyers, politicians, and other elite of his city's circle tempted him not only to live like a nabob but also to indulge in business (usually with disastrous results). He kept in firm touch with the city around him. He wrote letters to the newspaper about the sidewalks in front of his house and the potholes around the corner, or to the "goddamn" gas company about its failings. He gave humorous fundraising lectures at both a gilt-edged church attended by the elite and an African American church with humbler parishioners. He campaigned for local politicians he admired (and often later despised). And he enjoyed weekend walks with his friend Twichell to those blue hills in the western distance.

Later, economic disaster drove him out of the city, and a deep personal tragedy turned Hartford into "the city of Heartbreak." In old age, as he dictated his autobiography to a stenographer, striding around the office in his New York home, Hartford's stories stayed with him, as the important stories always did.

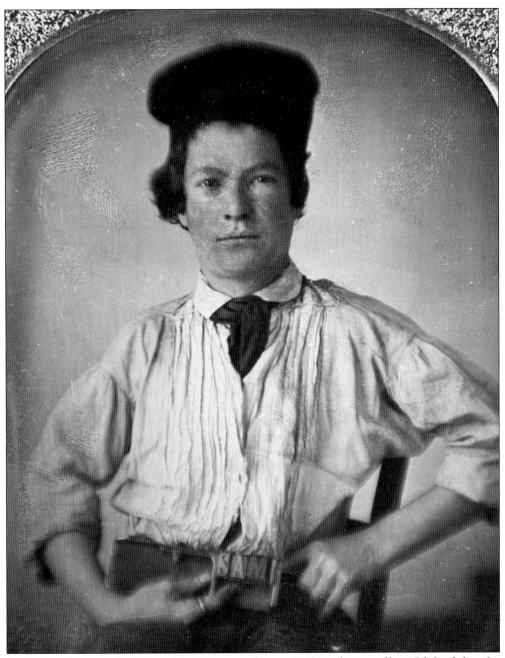

In the first photograph of Samuel L. Clemens, taken in 1850 on the eve of his 15th birthday, the young printer's devil holds a setting stick, in which the individual pieces of type are arranged as they eventually will be set for letterpress printing. This was the only kind of printing the young Clemens was familiar with; mechanical typesetting was an invention of his mature years. (Courtesy of the Mark Twain Papers and Project, Berkeley.)

One

ORIGINS

Samuel Langhorne Clemens was born in Florida, Missouri, on November 30, 1835, an event that he said raised the population of the village by one percent. The family moved to the river port of Hannibal—the St. Petersburg of the Tom Sawyer and Huck Finn books—when he was three years old. There, he attended school, but only until the death of his father in 1847. Shortly afterward, he took a job as errand boy for the *Hannibal Gazette*, then worked for other newspapers as an apprentice or printer's devil and then as a typesetter.

As he formed words into type by hand, he became a voracious reader of them—and then a writer of them, putting his natural storytelling skills to work in short newspaper pieces. In 1853, at 17, he went on the road, working for printers in New York and Philadelphia and seeing Washington for the first time. At 18, he sent a world-weary description of Congress to his brother Orion's Iowa paper: "The Senate is now composed of a different material from what it once was. Its glory hath departed." In his 20s, he apprenticed as a river pilot on the great Mississippi steamboats and acquired his license in 1859—fulfilling a lifelong dream. But the Civil War ended the river trade.

He served for two weeks in an ephemeral quasi-Confederate regiment, then traveled west with his brother Orion, who had been appointed secretary of the Nevada Territory. Clemens turned his hand unsuccessfully to silver mining, then fell back into newspaper work at the *Virginia City Territorial Enterprise*. There, in 1863, he took on the pen name Mark Twain, taken from the cry of a steamboat crewman sounding the river's depth at two fathoms.

Eventually, he found his way to San Francisco, and there, in 1865, his tale of a frog-jumping contest, related circuitously and ramblingly by one Jim Smiley and involving a heavy dose of cheating by means of buckshot, became wildly popular and made his name nationwide. In June 1867, he was sent by the *Alta California* newspaper to report on the first post–Civil War ocean cruise. In December, publisher Elisha Bliss proposed a book based on this voyage—and the next month, Mark Twain came to Hartford.

Clemens's childhood in Hannibal, Missouri, supplied him with adventure, characters, and scrapes enough to create great literature in Hartford: "After all these years I can picture that old time to myself now, just as it was then: the white town drowsing in the sunshine of a summer's morning." This family home is now the centerpiece of the Mark Twain Boyhood Home and Museum complex.

Clemens remembered his mother, Jane Lampton Clemens, as his "first and closest friend," a woman who, like him, "felt a strong interest in the whole world and everybody and everything in it." She carried on a "game of chaff"—affectionate banter—with him all her life and lived to be 87. "She never used large words, but she had a natural gift for making small ones do effective work."

Hannibal boys saw steamboat piloting as the apex of achievement, so Clemens believed he was set for life when he earned his pilot's license in 1859. Two years later, however, war between the North and South cut the Mississippi in half. Clemens narrowly escaped being ordered to pilot for the Union, drilled briefly as a Southern sympathizer, then headed west with his brother.

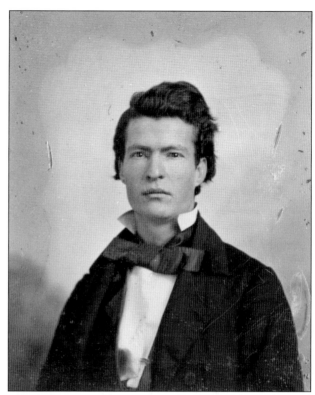

Later, in Hartford, Clemens wrote about his experiences in the West—the long trip to Nevada by stagecoach, the silver-mining fever, the territorial politics of the time, the violence, the funny stories, and this experience with a horse—and finally, his 1862 debut in the *Virginia City Territorial Enterprise*, where he became Mark Twain. A bad joke in his paper got him in trouble, and he headed for San Francisco in 1864.

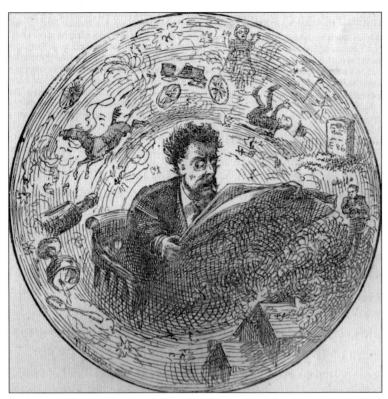

In San Francisco, he started a round of police, court, and fire coverage that he called "awful slavery for a lazy man." He was finally freed to write the humorous sketches he preferred—and the serious ones, attacking corruption and anti-Chinese prejudice in the city. He began to be published further afield and won a national stage with the tale now known as "The Celebrated Jumping Frog of Calaveras County."

Clemens's dream assignment for the *Alta California*—accompanying a group of pleasure-seekers on a cruise through the Mediterranean—took him to museums and cathedrals (where he and his shipmates tormented guides with comments of deadpan innocence) and finally to the Holy Land in the Middle East. In his dispatches home, he satirizes innocent Americans and sophisticated Europeans alike, often with bad puns.

ON A BUST.

One fellow traveler, bushy-eyebrowed Charles J. Langdon of Elmira, New York, had turned 18 when he sat for this portrait in Alexandria, Egypt. (A guide and another passenger stand behind him.) The boy had by this time changed Clemens's life, having shown him a miniature portrait of his sister Olivia "Livy" Langdon, on shipboard. "From that day to this she has never been out of my mind," Clemens wrote four decades later.

Olivia Langdon was the daughter of Elmira's wealthiest family, who were deeply involved in the abolitionist movement. She was educated in the local female seminary, and Clemens remained smitten by her beauty and intelligence when they met in New York in December 1868 and attended a reading by Charles Dickens. She was 22.

The same month Clemens started courting Livy Langdon, Elisha Bliss of Hartford's American Publishing Company wrote him: "We are desirous of obtaining from you a work of some kind, perhaps compiled from your letters from the East, &c." Clemens replied with interest, and in January 1868 he was on his way to Hartford to see Bliss.

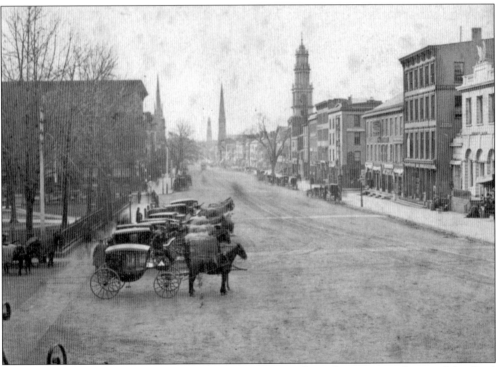

Hartford in 1867 was a lively place, making the transition from the economic boom of the Civil War to civilian manufacture, but the backbone of its industry remained its great insurance companies and banking houses. "Puritans are mighty straight-laced, & they won't let me smoke in the parlor, but the Almighty don't make any better people," Clemens wrote. This view looks south on Main Street.

Two

THE CITY

Hartford lies in the lowland along the Connecticut River, which determined the city's role as a port and, by extension, ultimately as an insurance center. The view in 1868 from that river looking east would have shown a low-rise brick-and-wood city, with a steamboat dock leading to a street that led up the hill to the statehouse with its Georgian brick dome. In a straight line with it—four to the right, four to the left—were church spires delineating Main Street. To the left, the south, Main Street crossed a small river, known at various times as the Little, the Hog, and the Park Rivers, which ran through downtown and curved around the city park before emptying into the Connecticut. To the far left on the South Meadows was the great arms factory of Elizabeth Colt, widow of Samuel, with its surrounding Coltsville workers' housing, ball field, and church. Straight ahead were the Italianate square twin towers of Union Station and the curve of track and switching yard. In the distance were more long, low redbrick factories and beyond that the green suburbs of Farmington and Asylum Avenues, beyond that fields and hills.

The city's most famous politician, Gideon Welles, returned to the city in 1869 after stints as secretary of the navy under both Abraham Lincoln and Andrew Johnson. A population of less than 30,000 in 1860 had grown to nearly 40,000. "Hartford has grown, and greatly altered," Welles wrote in his diary, "a new and different people move in the streets." About a quarter of those people were Irish immigrants, come to work in the factories and building neighborhoods and churches that threatened to dwarf the quiet residences of the Protestant middle class. Germans, Russians, and Italians added new exoticism to the mix. Poverty was rampant in the neighborhoods near the river. Business had declined at war's end, but the general tenor was that of a triumphal progress, economic drive, and the anticipation of an ever-rising prosperity.

It was a center of book publishing, too—just the place for an aspiring young author to come to get an important book into print.

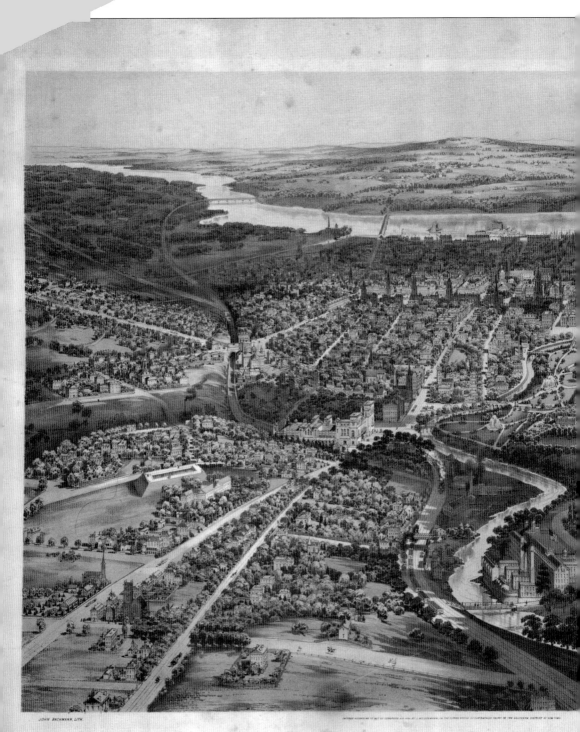

JOHN BACHMANN, LITH.

CITY OF HARTFORD, C

Published by J. WEIDENMANN, Hartford, Conn.

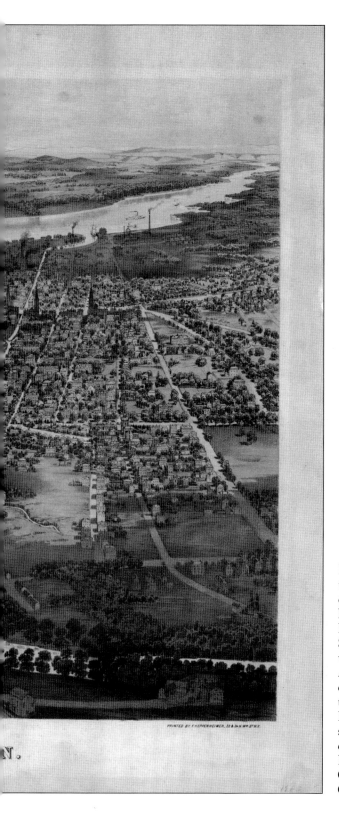

PRINTED BY F.HEPPENHEIMER. 22 & 24 & W* 2d ST N.Y.

N.

In 1864, John Bachmann created this bird's-eye panorama of the city of Hartford, viewed from a spot hovering somewhere above Nook Farm, the neighborhood where Samuel Clemens first lodged as a visitor and was to build a home. Asylum and Farmington Avenues converge at lower left near the towered railroad depot, the great Pratt & Whitney plant takes center stage, and in the distance a line of church spires marks Main Street. Beyond that is the curve of the Connecticut River. (Courtesy of the Connecticut Historical Society.)

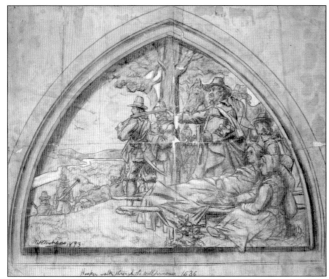

Hartford had its origins in 1635, when Thomas Hooker, an English Puritan minister who briefly led a church in what is now Cambridge, Massachusetts, traveled with his ailing wife, his parishioners, and herds of cattle on an eight-week journey through the forest to settle on the Connecticut River. This sketch is for a bas-relief on a state capitol arch. (Courtesy of the Library of Congress.)

One of the proudest moments of Connecticut Colonial history came in 1687, when representatives of a new regime in England tried to revoke the colony's charter at a meeting in Hartford. At the moment of the handover, the candles went out, and the document was taken to be hidden in a nearby white oak tree. Ever after called the Charter Oak, the tree stood as a tribute to American liberty until it fell in a storm in 1856.

A view north along Main Street culminates in the square tower of Christ Episcopal Church. Small businesses, offices, warehouse, and small factories—including a coffin factory—dominated the low-rise street and its feeder side streets in the late 1860s. Wagons parked along the street in the early morning waited for, or delivered, goods.

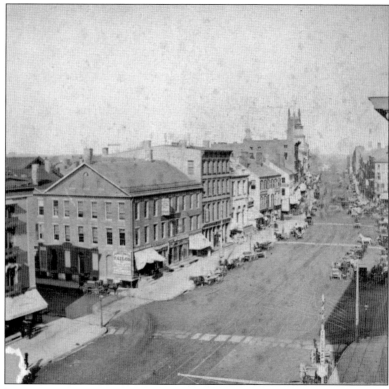

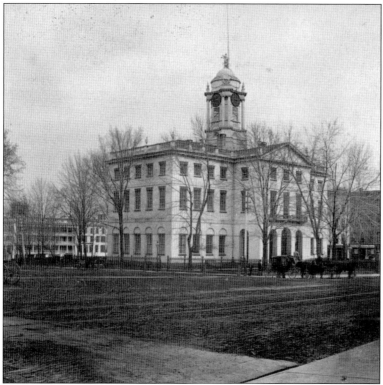

The Connecticut Statehouse was built in 1796 and is reputed to be architect Charles Bulfinch's first public building. The trial of the African rebels on the slave ship *Amistad* was held there in 1839, and in 1859 two men climbed to the cupola and shrouded the statue of justice in mourning on the day Connecticut's John Brown was hanged in Virginia.

21

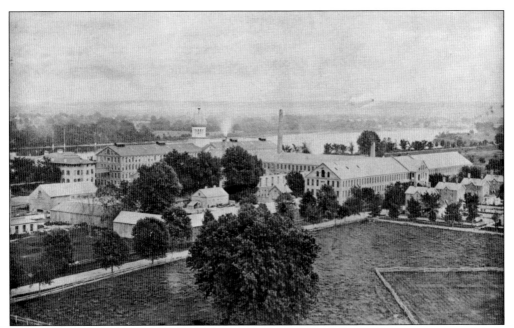

The Colt factory sprawled along the riverside south of Hartford on 260 flat acres, protected from river flooding by a massive dike. Built by the inventor and entrepreneur Samuel Colt, it supplied arms to the Western territories and armies in Italy, Hungary, the Ottoman Empire, and Russia. Colt died in 1862, but his wife, Elizabeth Colt, took over ownership of the plant and became a major figure in Hartford philanthropy.

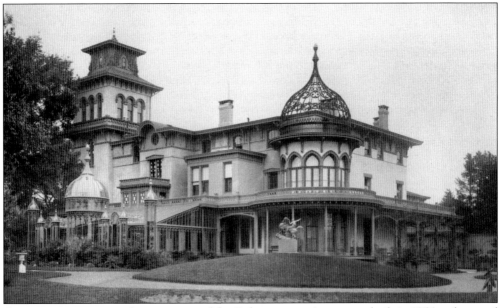

Arms were written into the very name of the Colt mansion, Armsmear, built in 1856 and a grand testament to Hartford wealth. The exotic glass conservatory attached to the house sported "a beautifully shaped dome & painted little minarets . . . like a fairy palace," according to Isabella Beecher Hooker. Hooker, sister of Harriet Beecher Stowe, was to be Samuel Clemens's first hostess in Hartford.

Armsmear trumpeted the wealth that could be produced from the instruments of war and presaged the Gilded Age that Clemens was to satirize and admire. Its extensive grounds were meticulously landscaped and spread with gardens, lakes, fountains, and statuary. Hebe, goddess of youth and cupbearer to the gods, pours wine into a goblet.

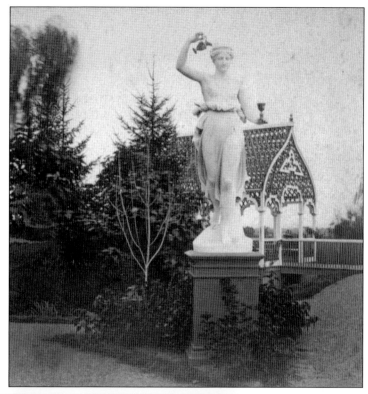

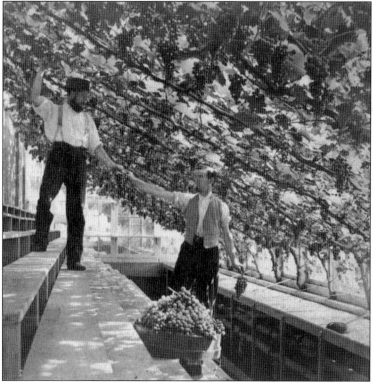

Workers in an Armsmear greenhouse pick grapes, a rare dish in wintry Hartford, available only to the wealthy. The conservatory, 40 feet wide and topped with a golden apple, was a high point of the Armsmear pastoral scene, which also included a working farm—within sight of the great blue-domed armory and the community of workers called Potsdam Village.

The bedrock of Hartford industry was insurance. The founding legends of these companies are many—the Travelers Insurance Company, for example, is supposed to have sold its first policy for 2¢ to a friend of founder James Batterson, guaranteeing that the man could walk two blocks without accident. Pictured here is the Phoenix Mutual Life Insurance building on Pearl Street.

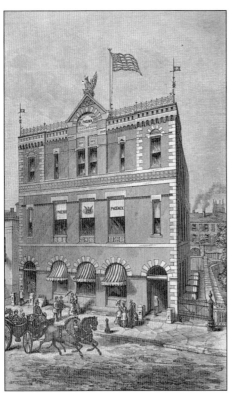

Francis A. Pratt and Amos Whitney, both of whom had worked for Colt, formed their iconic company in 1860, designing and building the machine tools other manufacturers needed to make sewing machines and other modern devices. During the Civil War, the company produced machinery to make guns. Pratt & Whitney, with its brick plant on the Park River, was incorporated postwar.

Daniel Wadsworth, the son of a Revolutionary War–era merchant and diplomat, built his athenaeum on Main Street in 1844—a Gothic Revival building dedicated to promoting the arts and sciences. It included a library, a collection of paintings and statuary, natural history exhibits, and the state's historical society. It still stands as the entry point to the Wadsworth Atheneum Museum of Art.

The Reverend Horace Bushnell was a major figure in 19th-century Hartford and known nationally—his travels even took him to distant California, where he helped found the state's first university. In Hartford, he was known as a religious reformer—once nearly tried for heresy—and a civic reformer. His city park, today Bushnell Park, replaced blight with open space in the city's heart.

Bushnell's park covered more than 50 acres within a curving arm of the Park River. In 1853, the minister proposed that the city build it with public funds—an innovation previously unheard of. But Bushnell, who thought urban life should consist of "outdoor parlors" where rich and poor could "exchange looks," persisted, and the park was built.

West of the city, a long avenue ran toward the nearby village of Farmington. About two miles from Main Street, it crossed a stream, and a traveler might look left to see a steep slope plunging dramatically toward the placid brook. Here, two local lawyers had bought an old farm, subdivided it, and called it Nook Farm—the site of Samuel Clemens's Hartford home.

Three

ARRIVALS

When Clemens returned from his trip to Europe and the Holy Land in November 1867, he did not return to San Francisco right away, but in print he kept the *Alta California* readers aware of his doings. These included stints in Washington, DC, as secretary to a senator, correspondent for New York papers, and close witness to the politics of Reconstruction.

In December, he visited New York and met the entire family of his teenage shipmate Charlie Langdon—with a particular eye for Langdon's sister Livy, whom he had seen in that portrait miniature on the Bay of Smyrna. The group went to hear Charles Dickens read from *David Copperfield*, but as Clemens tells his San Francisco readers, "I am proud to observe that there was a beautiful young lady with me." This was the start of his courtship.

In late January came the business trip to Hartford to see the publisher Elisha Bliss, during which Clemens stayed with the Hookers. He wrote to another *Quaker City* passenger, "I don't dare to smoke after I go to bed, & in fact I don't dare to do *anything* that's comfortable & natural." But he wrote glowingly of the city in his *Alta* letters, and when he got back to New York a few days later, he wrote an old Missouri friend: "I have made a tip-top contract for a 600-page book, & I feel perfectly jolly."

Clemens carried on an extensive courtship by letter with Livy Langdon—she rejected him at first, then accepted him. He returned to Hartford in the fall to work with Bliss on manuscripts; according to a Bliss descendant, one of the publisher's sons had the job of picking up cigar stubs from outside Clemens's windows each morning. He went on lecture tours, a lucrative but unloved business that took him far from the East. And he made an important close friendship, with the Reverend Joseph Twichell of Hartford's Asylum Hill Congregational Church, that lasted 42 years.

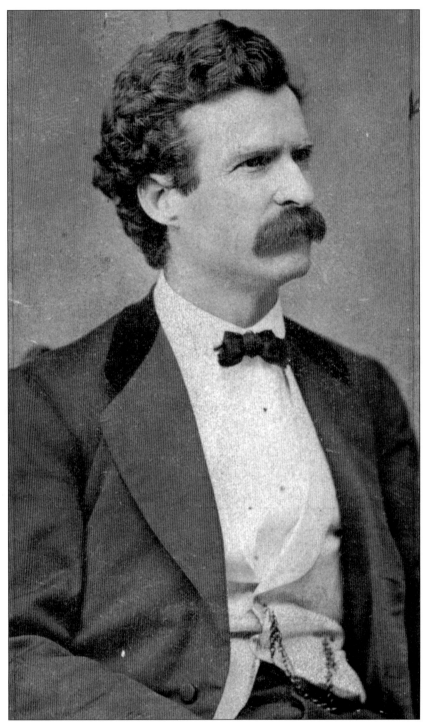

Samuel L. Clemens entered Hartford like a conquering hero, proud of the negotiation from a position of strength he had carried on with the American Publishing Company for a book on the *Quaker City* voyage. "I thought I would cut the matter short by coming up for a *talk*," he wrote to his mother and sister of his dealings with Elisha Bliss.

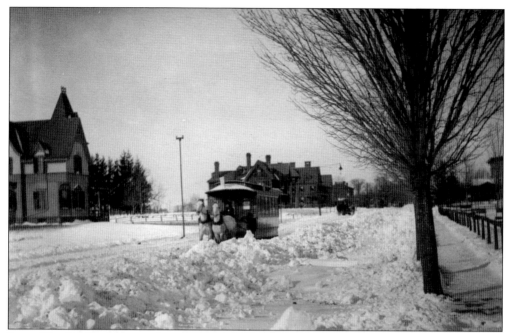

It was New England winter when Clemens arrived; in this view, a horse-drawn streetcar struggles along Farmington Avenue near the Nook Farm neighborhood where he lodged. In wry comments on the city sent to the *Alta*, he wrote, "Hartford has a population of 40,000 souls, and the most of them ride in sleighs. That is a sign of prosperity, and a knowledge of how to live—isn't it?"

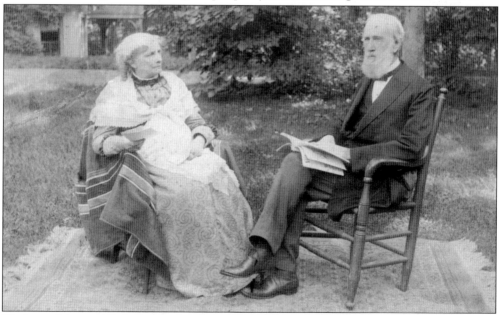

His hosts John and Isabella Beecher Hooker were, like many in the Nook Farm community, dedicated progressives and eccentrics. John, with fellow lawyer and abolitionist Francis Gillette, had founded the neighborhood. A half sister of Harriet Beecher Stowe, Isabella was one of the extraordinary Beecher family. Isabella fought for women's rights alongside Susan B. Anthony and others.

"All those Phoenix and Charter Oak Insurance Companies, whose gorgeous chromo-lithographic show-cards it has been my delight to study in far away cities, are located here," Clemens wrote in the *Alta*. Phoenix had insured Abraham Lincoln; by the time Clemens got to town, Aetna (named for a volcano in Sicily) had diversified into farm mortgage loans in the West.

"They have the broadest, straightest streets in Hartford that ever led a sinner to destruction," Clemens wrote. "I am able to follow Main street, from the State House to Spring Grove Cemetery, and Asylum street and Farmington avenue [shown], from the railway depot to their terminations. I have learned that much of the city from constant and tireless practice in going over the ground."

Hartford's dwelling houses were "massive private hotels, scattered along the broad, straight streets, from fifty all the way up to two hundred yards apart. Each house sits in the midst of about an acre of green grass, or flower beds or ornamental shrubbery, guarded on all sides by the trimmest hedges of arbor-vitae, and by files of huge forest trees that cast a shadow like a thunder-cloud."

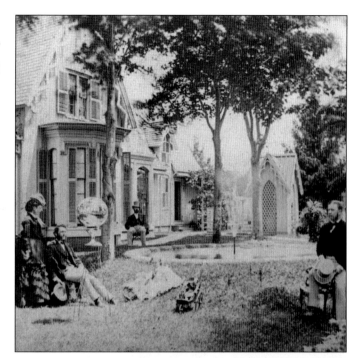

"Some friends went with me to see the [Colt] revolver establishment . . . There are machines to cut all the various parts of a pistol, roughly, from the original steel; machines to trim them down and polish them; machines to brand and number them . . . I took a living interest in that birth-place of six-shooters, because I had seen so many graceful specimens of their performances in the deadfalls of Washoe and California."

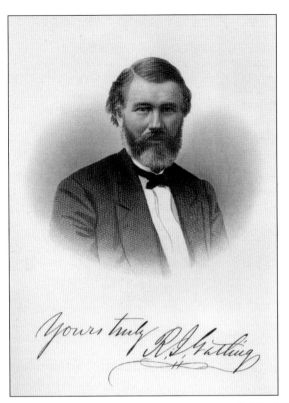

Clemens fired a Gatling gun: "You work it with a crank like a hand organ; you can fire it faster than four men can count. When fired rapidly, the reports blend together like the clattering of a watchman's rattle. It can be discharged four hundred times in a minute! I liked it very much, and went on grinding it as long as they could afford cartridges for the amusement." Dr. Richard J. Gatling (pictured) had contracted for his famed gun to be built at the Colt Armory.

"Set a white stone," Clemens wrote Livy, "for I have found a friend." The Reverend Joseph Twichell had origins in rural Connecticut, graduated from Yale, and served for three years as a Union chaplain before settling into his Hartford parish. The two men hit it off immediately and were soon engaging in lengthy walks and conversation—talk that ranged from points of grammar and Mississippi tales to deep issues of God and humanity.

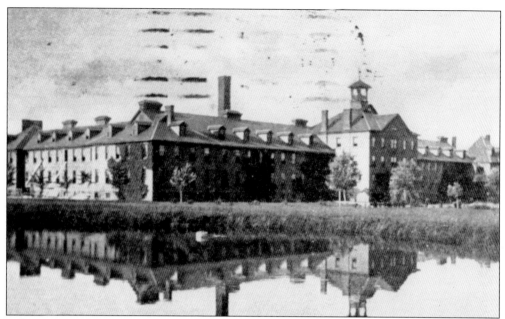

"Then, where are the poor of Hartford? I confess I do not know," Clemens had written to the *Alta*. Now, his friend Twichell took him on a ministerial visit to the city almshouse: "Heaven & earth, what a sight it was! Cripples, jibbering idiots, raving madmen; thieves, rowdies, paupers; little children, stone blind . . . I have not had anything touch me so since I saw the leper hospitals of Honolulu & Damascus."

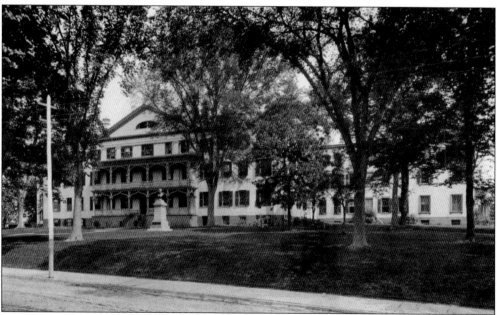

Asylum Hill's name came from the American Asylum for the Deaf and Dumb. Education for the hearing-impaired was a strong Twichell interest. He later invited Clemens to lecture there—attractive young women would be doing the signing for the deaf, he said. The school, today West Hartford's American School for the Deaf, was a pioneer in its field, founded by Thomas Gallaudet in 1817.

When *The Innocents Abroad* rolled off the presses in July 1869, it was an instant best seller. Within its first year, it sold 70,000 copies, a blockbuster in that era. Reviewers loved its mix of vivid travel writing and satire and the uniquely American voice and style of its author. It remained Clemens's best-selling book for the rest of his life.

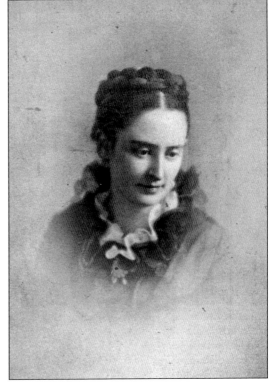

Olivia Langdon had said "yes" to Clemens's proposal in the fall of 1868. She was the daughter of a wealthy family in Elmira with Hartford connections and had been educated at Elmira College. Clemens used biblical language when she accepted: "Sound the loud timbrel & let yourself out to your most prodigious capacity—for I have fought the good fight & lo! I have won!" They were married in February 1870.

Jervis Langdon, Livy's father, was a self-made man. By the 1860s, he had extensive interests in Western lumber forests, coal mines, and shipping. After Livy and Clemens were engaged, Jervis loaned the author money to buy an interest in a Buffalo, New York, newspaper, and bought the newlyweds a home to go with it.

According to Elmira tradition, before the Civil War, Olivia Lewis Langdon and her children delivered food secretly to the escaped slave John W. Jones. (Jones went on to rescue 800 slaves as a local Underground Railroad conductor.) The family had been friends with Frederick Douglass, Gerrit Smith, and other abolitionists.

Thomas K. Beecher was the Langdon family's pastor in Elmira and performed the Clemenses' marriage along with Twichell. Yet another of the Beecher clan, he was a progressive and opinionated minister, and built a vast church as a community center, with billiard tables and bathtubs available to all.

Mary "Mother" Fairbanks was a Cleveland newspaper editor's wife whom Clemens had met on the *Quaker City* trip. He kept her well apprised of his progress with Livy and confided his doubts about Buffalo: "The more I thought of trying to transform myself into a political editor, the more incongruous & the more hazardous the thing looked. I always did hate politics."

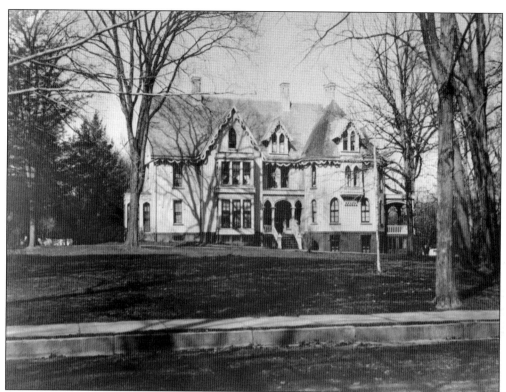

In Buffalo, the Clemenses were beset by tragedies—the death of an old friend and of Livy's father. A difficult pregnancy resulted in the premature birth of their first child, Langdon Clemens, on November 7, 1870. They made the move to Hartford in October 1871, renting the Hookers' home in Nook Farm (pictured) and planning to build a house.

Though the Clemenses were happy to be among their new neighbors and friends in the intellectual fellowship of their neighborhood, tragedy followed them. Slow to develop, Langdon contracted diphtheria in the spring of 1872 and died. Samuel Clemens blamed himself, thinking that a carriage ride in the cold had been the cause.

37

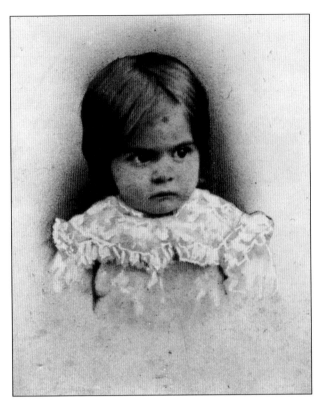

Langdon died when his sister Olivia Susan Clemens was just two-and-a-half months old. She was a spirited child, dubbed the "Modoc" by her parents, and Susy—as she was ever known—provided consolation for the family's loss.

In January 1872, Clemens published a book based on his experiences in the West in the early 1860s—*Roughing It*, a mix of autobiography, travelogue, tall tales, and wild humor. In this illustration, *The Miner's Dream*, Clemens, in his prospecting days, dreams of an elegant life he might one day lead—a life that in fact was now beginning in Hartford.

Clemens was first rejected as a partner by Charles Dudley Warner, co-owner of the *Hartford Courant*, but after *The Innocents Abroad*, the owners were eager to invite him in. Clemens enjoyed his revenge and refused. The two men were Nook Farm neighbors and became close friends. Urged by their wives, they collaborated on a novel, *The Gilded Age*.

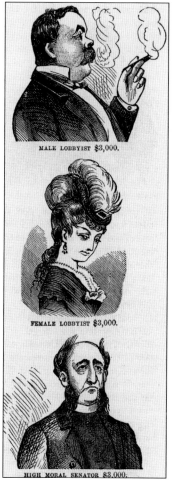

MALE LOBBYIST $3,000.

FEMALE LOBBYIST $3,000.

HIGH MORAL SENATOR $3,000.

The novel Clemens and Warner produced and published in 1873 is an odd mix of styles—Warner's chapters breezy and lightly humorous, Clemens's more intricate and earthy. But the book gave their era a name that has stuck. It tells a dramatic tale of Washington corruption, predatory lobbyists (left), and crooked land deals in the West linked by a melodrama of love, betrayal, and redemption.

In a whimsical mood, Clemens and Warner asked John Hammond Trumbull—a renowned linguist and scholar who presided at the Wadsworth Athenaeum's library—to provide mottos for each chapter. The mottos run the gamut from Tuareg to Arawak to Sioux and offer an esoteric challenge to the reader.

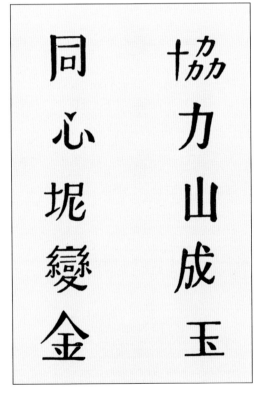

The leading motto provided by Trumbull is in Chinese and marks the two authors' collaboration: "By combined strength, a mountain becomes gems; by united hearts, mud turns to gold." The motto could also stand for the family collaboration of Samuel and Livy Clemens as they embarked on their Hartford life.

Four

A HOME

When Samuel and Livy Clemens moved into their leased home in Hartford in 1871, they fully intended to build a house in the city. Even before their marriage and stint in Buffalo, Clemens wrote to his good friend Reverend Twichell: "My future wife wants me to be surrounded by a good moral & religious atmosphere (for I shall unite with the church as soon as I am located,) & so she likes the idea of living in Hartford." His piety was sincere—in marked contrast to the later Clemens, known for his skepticism. The next day, he wrote to Livy: "What we want is a home."

Their rented home was in the right neighborhood—Warner and his newspaper partner, war hero and politician Joseph Hawley, were nearby, so was Harriet Beecher Stowe and the Hookers, and Twichell was just a few blocks away. Neighbors provided support after the death of little Langdon, as they had celebrated the birth of Olivia Susan just three months before.

An attractive, if oddball, piece of property was nearby and on the market—a long and thin strip, set at right angles to Farmington Avenue, that included the dramatic slope down to the Park River's North Branch. Livy had her eye on it right away, and ultimately the sale was closed. A neighbor offered the name of an architect—a New Yorker best known for collegiate buildings and churches—and the building got under way in 1873.

Livy Clemens had more interest in the details of the project than Samuel Clemens, who later said he had no interest in seeing a new house until "a cat was purring on the hearth." But Livy, who acknowledged that "Mr. Clemens knew nothing about houses on paper," got him into the spirit. "Mr. Clemens seems to glory in his sense of possession," she wrote her sister, "he goes daily into the lot, has had several falls trying to lay off the land by sliding around on his feet."

Lilly Gillette Warner, daughter of a Nook Farm founder and sister-in-law of the editor and author Warner, and her husband, George, had retained the architect Edward Tuckerman Potter to build their Nook Farm home. They had nothing but praise for him. "I want immensely to get that house for Potter," George wrote to her about the Clemenses' future home.

The Warner house was built in "the English style," as a newspaper describes it, a whimsical, detail-filled structure of decorated brick and lavish porches, topped with elegant, broad chimneys imitating British homes of Elizabethan days. It was still being built as the Warners lobbied with the Clemenses to use Potter.

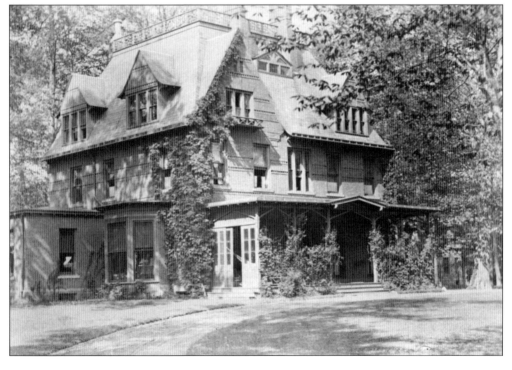

Edward Tuckerman Potter had apprenticed with a leader of the American Gothic Revival, Richard Upjohn and designed the 16-sided Nott Memorial building at Union College in Schenectady, New York, along with many churches. Among these was the Church of the Good Shepherd built for Elizabeth Colt in the city's South Meadows; the church represented the family trade in its stone carvings of crossed six-shooters on its south porch.

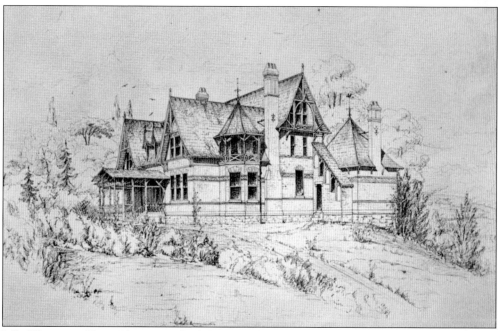

Lilly Warner and Livy Clemens walked the grounds, discussing how to orient the new house. The narrowness of the property made it unlikely that it could face Farmington Avenue. Warner said it was time to bring in an architect, and she wrote to her husband triumphantly, "They preferred Mr. Potter to anyone else." Potter soon produced this sketch.

MARK TWAIN'S HOUSE

BUILT 1874 EDWARD TUCKERMAN POTTER, ARCHITECT

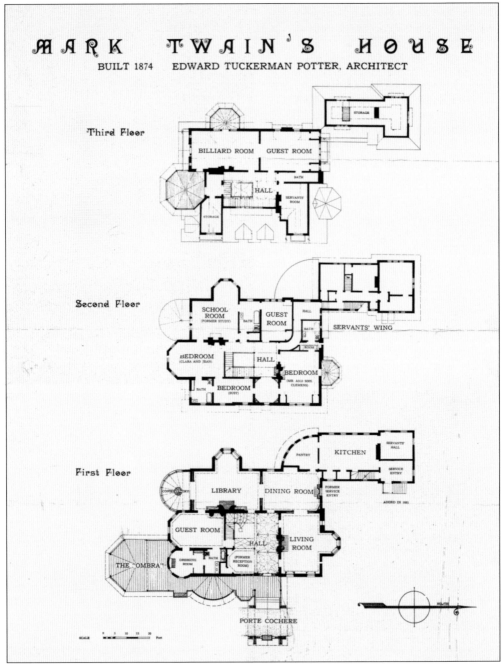

The plan was for a three-story house. While this is a more recent version of the home's plan, including changes the Clemenses made later, the general idea was the same. The ground floor included the public areas of the house, the second floor held the bedrooms and nursery, and the third floor was anchored by Clemens's billiard room.

While the house was under construction, starting in spring 1873, the Clemenses were confident enough to take an extended trip abroad to England and Scotland, with jaunts to Ireland and France. While there, they visited Dr. John Brown, author and physician, shown here with the Clemenses and one-year-old Susy in the lap of Livy's friend Clara Spaulding.

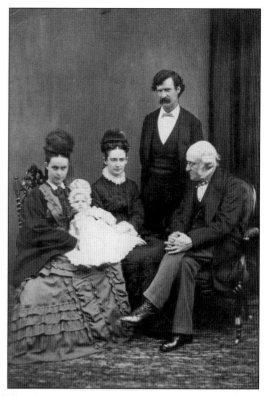

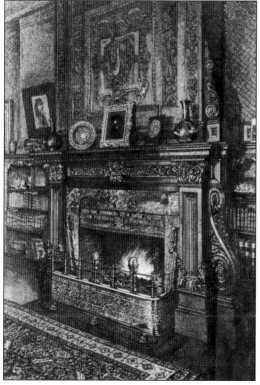

Also in Scotland, the Clemenses purchased items for their house, including this oak chimneypiece, which had been made for a castle. Paris was another source of furnishings. On their return, they visited the site frequently. Livy was now pregnant, and a workman saw "Mark Twain pick her up in his arms and gaily mount the stairs, the pair laughing and chiding one another."

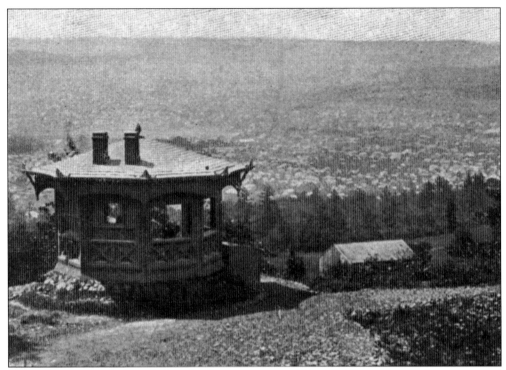

Construction provided a side benefit: Potter associate Alfred E. Thorp designed an octagonal study on a hill next to Quarry Farm, the home of Livy's sister Susan Crane and her husband, Theodore, in Elmira, New York. During the two decades they lived in Hartford, the family spent most of their summers there, escaping the heat that settled into the Connecticut River valley. (Courtesy of the Mark Twain Papers and Project, Berkeley.)

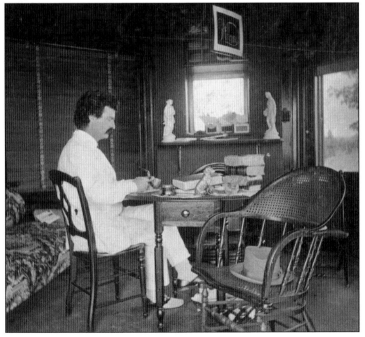

For Clemens, shown in the Elmira study, these were working summers. Much of *Huckleberry Finn* and other works were to be written here. Clemens wrote to Twichell about the study: "It sits in perfect isolation on top of an elevation . . . & when the storms sweep down the remote valley & the lightning flashes among the hills beyond, & the rain beats upon the roof over my head, imagine the luxury of it!"

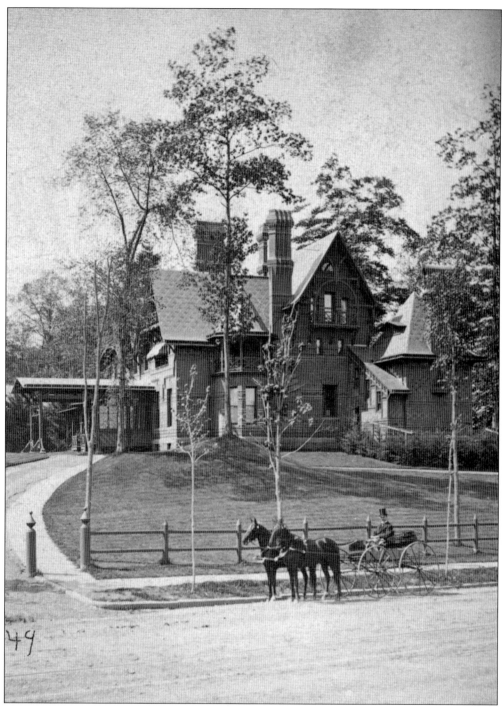

On a rainy September day in 1874, the Clemenses, returning from Elmira with newborn Clara, made their way by livery wagon from the Hartford railroad station to their new home. "Full of workmen yet," Clemens wrote. The family took up quarters on the second floor, as construction continued on the first. "We are comfortable," he wrote, "when the banging of the hammers stops for a while."

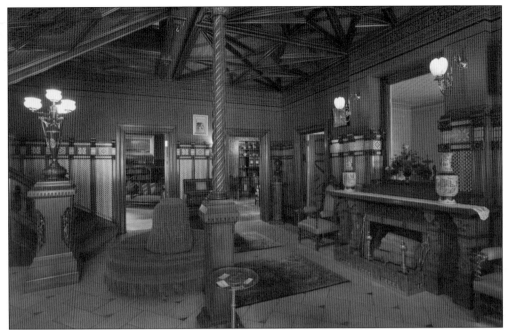

Today, the house is restored as a museum. When the Clemenses arrived in 1874, this entry hall was divided into smaller rooms, and the walls were relatively undecorated. An early visitor marked the "Alice in Wonderland" effect of the window over the fireplace. Visitors still check it to arrange their hair before realizing they are looking into the next room.

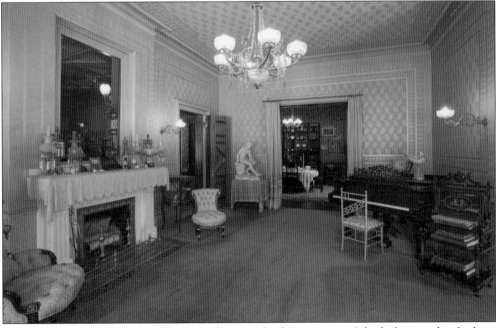

Visitors were ushered by butler George Griffin into the drawing room. It had a bay window looking over the "outer landscape of Farmington Avenue and the country beyond," architect Potter said. In the evenings, female members of a dinner party would sip coffee here while the men enjoyed brandy and cigars in the dining room.

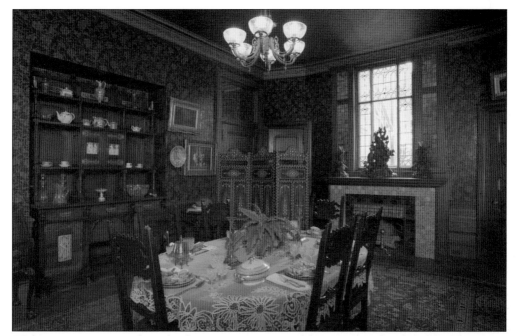

With construction complete, the dining room was one of the important locales of the Clemenses' entertaining. During the evenings, the room filled with the aromas of good food and rang with Clemens's rare and funny stories. Guests said he would tell his tales while rising from his seat and pacing back and forth behind the seated guests.

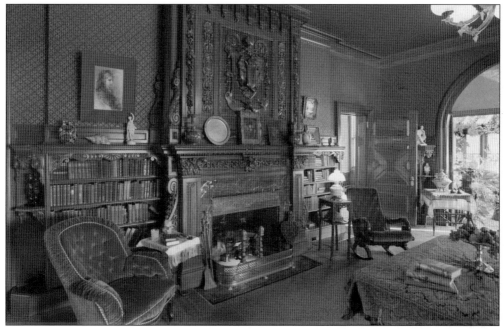

The library was the entertainment center of the Clemens house. The books that lined the shelves provided adventure, history, poetry, and visions of faraway places. For Susy and Clara, it was a magical place where their father told stories in which paintings, dishes, urns, and fireplace tongs became characters.

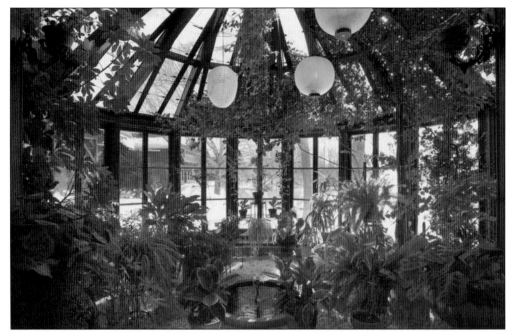

The conservatory at the end of the library allowed the Clemenses to bring the tropics into their winter home. It also provided a place for Susy's and Clara's father to play elephant on hands and knees, carrying them on his back through the jungle—boldly facing attacks from a tiger, portrayed by Griffin, the obliging and indulgent butler.

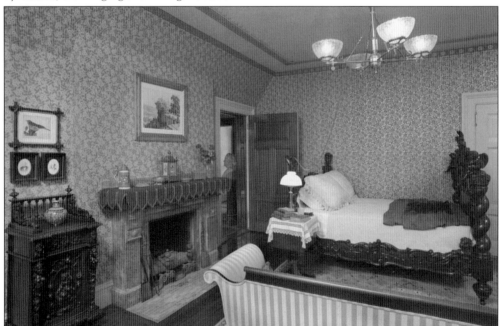

The master bedroom on the second floor eventually became home to a great Italian black walnut bed, which Clemens admired: "The most comfortable bedstead that ever was, with space enough in it for a family, and carved angels enough to bring peace to the sleepers, and pleasant dreams." The angels at each corner of the bed were removable and became dolls for the girls.

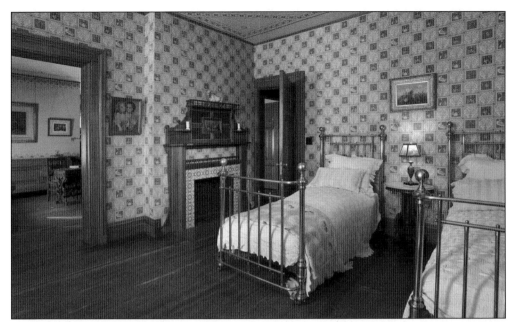

First Susy and Clara and their nurse, and later sister Jean, slept in the nursery, today decorated, as in the Clemenses' era, with wallpaper designed by the English children's book artist Walter Crane. A speaking tube between the two brass beds connected the children with the kitchen and the servants.

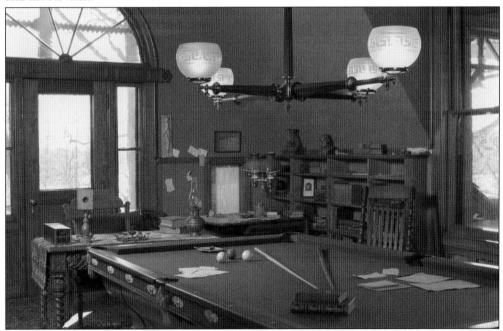

Though Clemens did not officially turn his billiard room into a study until 1880, he always found it a good place to write, play, and meditate on the view: "There is a cloud-picture in the stream now whose hues are as manifold as those in an opal & as delicate as the tintings of a sea-shell. But now a muskrat is swimming through it & obliterating it with the turmoil of wavelets he casts abroad from his shoulders."

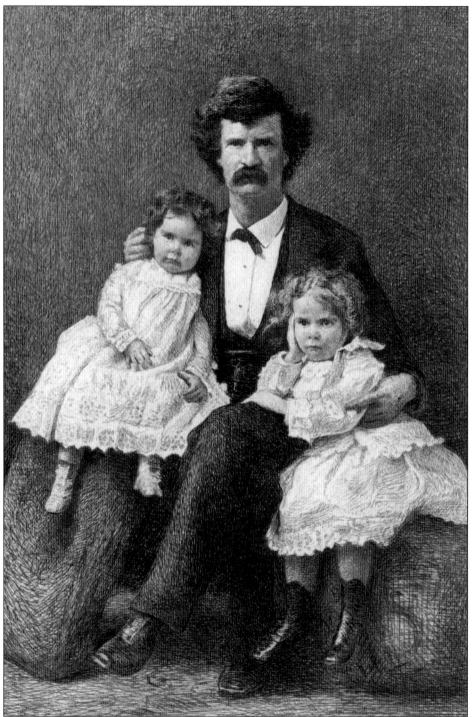

At last settled in his home, Samuel Clemens poses in 1877 for a photograph that has survived as a drawing. Susy was about five and Clara about three. None of them look very happy, but Samuel was in the midst of a decade of domestic happiness and productive literary work and deep involvement with, and affection for, his adopted city.

Five

THE SEVENTIES

Hartford continued to prosper in the 1870s—its banks remained largely stable even during the Panic of 1873, an economic slump that hit the nation hard. The decade had opened with another exciting incident in the insurance world, not always an exciting place. When fire swept Chicago in 1871, Connecticut governor Marshall Jewell, a director of the Phoenix Insurance Company, rushed to the scene and stood on a packing crate among the smoking ruins, assuring the crowd that every claim would be paid. The image boosted the city's title as the nation's insurance capital.

Settled into their new house in mid-decade, the Clemenses partook of the life of Nook Farm, inviting a constant flow of visitors to see the place and partake of their hospitality. Scandal divided Nook Farm during the much-followed adultery trial of a Beecher—Henry Ward, that is, another sibling of Harriet's and Isabella's and a national figure.

Clemens had started work on a new book, a "boy's book" about life among the boys of Hannibal, Missouri, with a main character named Tom Sawyer. He may have been telling his friend Twichell about the Mississippi River lore this work stirred up in his memory in the fall of 1874, when the two men took a walk in the woods. "What a virgin subject to hurl into a magazine," Twichell said, and Clemens started a series of river pieces for the *Atlantic Monthly*. A collection of short items called *Sketches, New and Old*—later, oddly, a favorite of Sigmund Freud's—came out in the 1870s, and after the indifferent success of *The Adventures of Tom Sawyer*, Clemens started a sequel about Tom's friend, Huck Finn. Late in the decade, the Clemenses made an extended visit to Europe, meant to supply furnishings for the house and another travel book to follow on the success of *The Innocents Abroad*.

Meanwhile, the family enjoyed a settled life—a first for Clemens—and the domestic pleasures and rituals of their house on Farmington Avenue. The house was a Hartford landmark: "It is one of the oddest buildings in the State ever designed for a dwelling, if not in the whole country," notes the *Hartford Times*.

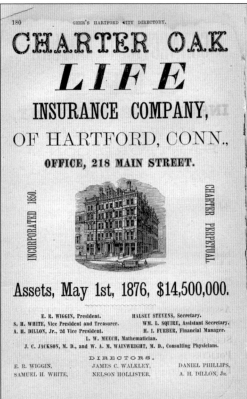

180 GEER'S HARTFORD CITY DIRECTORY.

CHARTER OAK
LIFE
INSURANCE COMPANY,
OF HARTFORD, CONN.,
OFFICE, 218 MAIN STREET.

INCORPORATED 1850. CHARTER PERPETUAL.

Assets, May 1st, 1876, $14,500,000.

E. R. WIGGIN, President. HALSEY STEVENS, Secretary.
S. H. WHITE, Vice President and Treasurer. WM. L. SQUIRE, Assistant Secretary.
A. H. DILLON, Jr., 2d Vice President. H. I. FURBER, Financial Manager.
L. W. MEECH, Mathematician.
J. C. JACKSON, M. D., and W. A. M. WAINWRIGHT, M. D., Consulting Physicians.

DIRECTORS.
E. R. WIGGIN, JAMES C. WALKLEY, DANIEL PHILLIPS,
SAMUEL H. WHITE, NELSON HOLLISTER, A. H. DILLON, Jr.

About a month after moving into his new house, Clemens summed up Hartford in a speech. He called it "a city whose fame as an insurance center has extended to all lands and given us the name of being a quadruple band of brothers working sweetly hand in hand." The first of these brothers was "the Colt's Arms Company making the destruction of our race easy and convenient."

The second brother was "our life insurance citizens paying for the victims when they pass away." *Geer's Hartford City Directory* includes this advertisement for one of the major life firms, Charter Oak, which did not have the staying power of others, failing late in the decade.

54

The third brother was "Mr. Batterson perpetuating their memory with his stately monuments." James Batterson, aside from his insurance pursuits, was a renowned monument maker in the city whose work included the Soldier's Monument in the National Cemetery at Gettysburg.

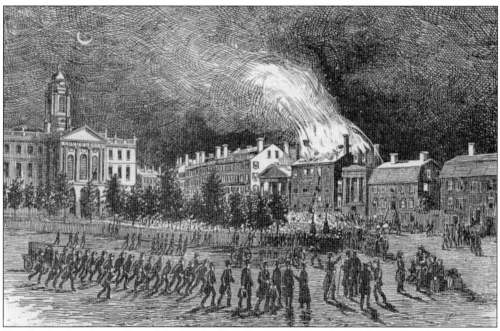

Finally, the fourth member of the band of brothers in Clemens's speech was "our fire insurance companies taking care of their hereafter." The portrayal here of an early Hartford fire near the statehouse was used as the heading for documents issued by a firemen's protective association in Hartford.

Several people commented on Clemens's sealskin coat and cap, in which he traveled the streets of Hartford, Boston, and New York in the wintertime. When he first met William Dean Howells, the editor and novelist who became a lifelong friend, Howells reported that Clemens "was wearing a sealskin coat, with the fur out, in the satisfaction of a caprice, or the love of strong effect which he was apt to indulge through life."

Less happy about the coat of sealskin was Lilian Aldrich, wife of the author Thomas Bailey Aldrich (pictured), who also disliked Clemens's practical jokes. The Aldriches visited Hartford, and Clemens criticized them one morning for the excessive noise they had made in bed above the hosts' room the night before. A mystified Livy explained to the mortified Aldriches that the guest bedroom was not above the Clemenses' room, and they had not heard a thing.

In *My Mark Twain*, written many years later, Howells paints a loving portrait of visiting Clemens at home, where the two friends "sat up late, he smoking the last of his innumerable cigars, and soothing his tense nerves with a mild hot Scotch, while we both talked and talked and talked, of everything in the heavens and on the earth, and the waters under the earth."

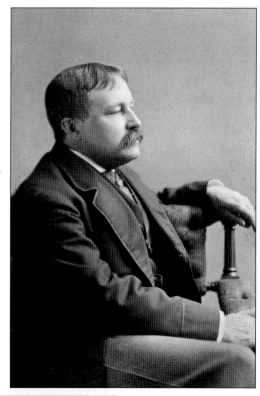

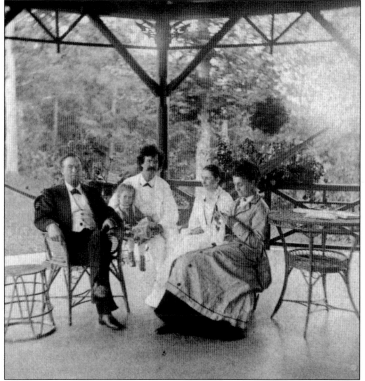

Old friends from the *Quaker City* excursion came to visit, including Dr. Abraham Jackson, the ship's doctor, and his wife, Julia, here seated with the Clemenses, including Susy. Jackson had taken part in some of the most interesting and funny exploits on the journey, including a moonlight illicit visit to the Acropolis. Clemens said Jackson harassed European guides by asking insanely stupid questions with the expression of "an inspired idiot."

Clemens faithfully attended his friend Twichell's Asylum Hill Congregational Church, once complaining to him that the sermon had been too interesting and kept Clemens from his own thoughts. In May 1875, he presided over a spelling bee at the church: "I don't see any use in spelling a word right—and never did . . . We might as well make all clothes alike and cook all dishes alike. Sameness is tiresome; variety is pleasing."

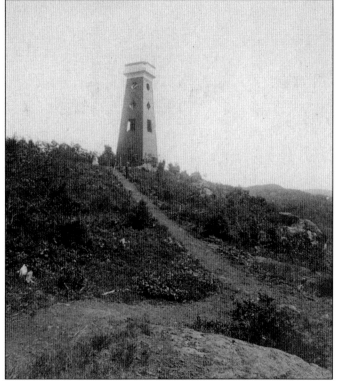

Clemens and Twichell made an autumn habit of the eight-mile walk from Nook Farm to Bartlett's Tower on the top of Talcott Mountain. The jaunt supplied them with the chance for exercise, but it was more for conversation: "We discussed everything we knew, during the first fifteen or twenty minutes, that morning, and then branched out into the glad, free, boundless realm of the things we were not certain about."

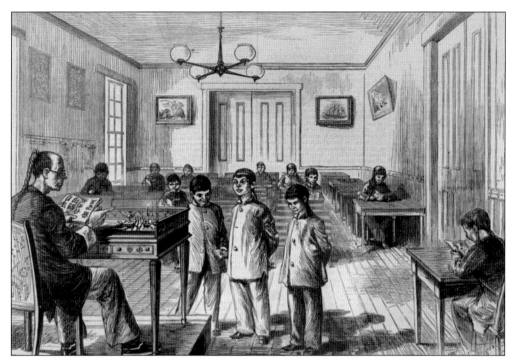

A cause close to Twichell's heart was the Hartford-based Chinese Educational Mission, an experiment in which the Qing Dynasty sent 120 boys to America to study—the first such effort ever. Clemens was enlisted to aid the effort. The Chinese government built the Hartford headquarters, where a *Harper's* magazine artist sketched a classroom scene.

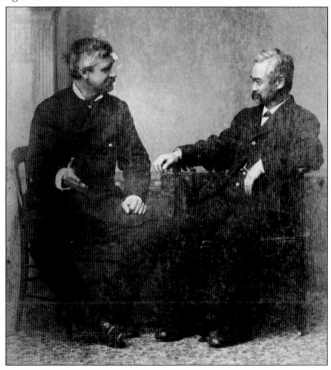

Twichell sits for a portrait with the Chinese Educational Mission's founder and director, Yung Wing, the first Chinese graduate of Yale. In the controversial waning days of the effort, Clemens was able to enlist the aid of former president Ulysses S. Grant to get its life extended, but a mix of American racism and Chinese conservatism doomed the experiment.

The year before the Clemenses moved in, Harriet Beecher Stowe and her husband, Calvin, moved from a nearby larger house to a simple Forest Street home. Their backyard abutted the Clemenses' front lawn. Now in her 60s, she had published *Uncle Tom's Cabin* 20 years before, bringing into sharp relief the horrors of slavery and making her the best-selling American author of the 19th century. She still wrote, but little after the 1870s.

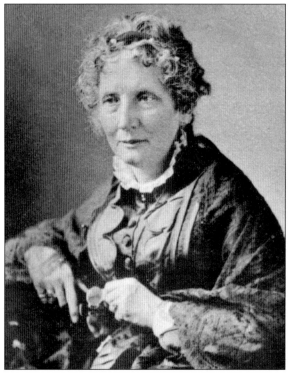

Stowe was a good friend, enthralling the guests at Clemens dinner parties with tales of antislavery days. In a famous incident, Clemens visited her without a tie; when Livy reproached him, he sent George Griffin with the tie on a tray. Stowe sent a note saying that he had discovered "the principle of making calls by installments." Clemens retorted: "I knew I had a principle around me somewhere."

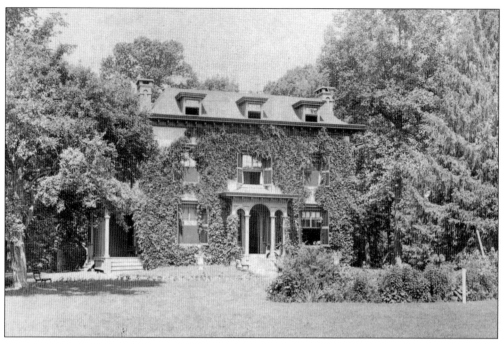

Francis and Eliza Gillette, whose house (pictured) was just down Forest Street, were also members of the prewar antislavery generation. Francis had developed Nook Farm with John Hooker. His obituary notes that he "could hardly have patience to wait for the emancipation proclamation."

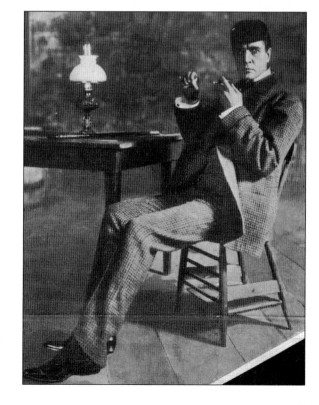

In 1874, the Gillettes' 20-year-old son, William, returned from New York to announce to his stunned Hartford neighbors that he had been acting in a theatrical version of *The Gilded Age*. The theater was morally suspect in Puritan Hartford, so he had kept a low profile. Gillette became a vastly famous actor, years later bringing the role of Sherlock Holmes to the New York stage.

In the 1870s, Charles Dudley Warner left the *Hartford Courant* largely in the hands of others and commenced on a literary career that had begun with *My Summer in a Garden*, a whimsical meditation upon life and politics. His forte was now as a travel writer, in Europe, Canada, and the Mediterranean. His *Backlog Studies* contains portraits of Clemens and Twichell, among others.

Susan Warner, Charles's wife, was a pianist and a major figure in musical Hartford, cofounding the Hartford Art School in 1877 with Livy Clemens, Stowe, and Elizabeth Colt. The musical events Warner held in her home presaged the city's 20th-century symphonic organizations. To the Clemens girls, the Warners were always "Aunt Susan" and "Uncle Charlie."

Just down the street lived Joseph Roswell Hawley and his wife, Harriet Foote Hawley, a Beecher cousin. Joseph was the major Connecticut political figure of the era—co-owner of the *Courant* with Warner and governor, congressman, and senator. Hawley was Hartford's national voice in this era.

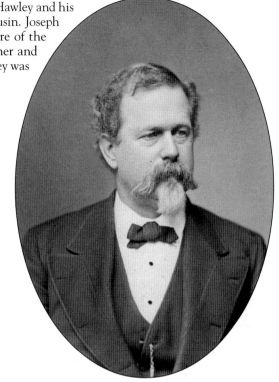

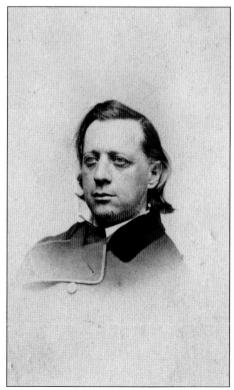

Scandal struck Nook Farm in 1873, when an official of Henry Ward Beecher's church in Brooklyn accused him of adultery. The alleged affair, with Elizabeth Tipton, and a court case that resulted became the focus of national attention for more than two years. Clemens and Twichell attended Beecher's trial for "alienation of affection," which ended in a hung jury.

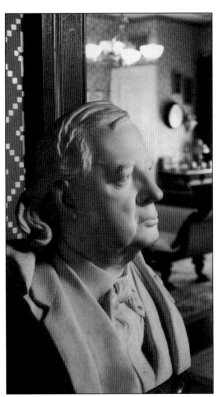

The Beecher scandal was set against the tremendous influence that he exercised as an abolitionist, a wartime inspiration, and a popular proponent of the gospel of Christ's love. The Clemenses stood firmly behind him—a bust of the preacher still graces their former home—and they shunned Isabella Beecher Hooker, who thought her brother was quite capable of what he was accused.

Below the Clemens house, skaters enjoy the frozen North Branch of the Park River where it passed below Farmington Avenue. In the 1870s, more homes were being built along the avenue, but it was still a place of pastures, ponds, and woodlands.

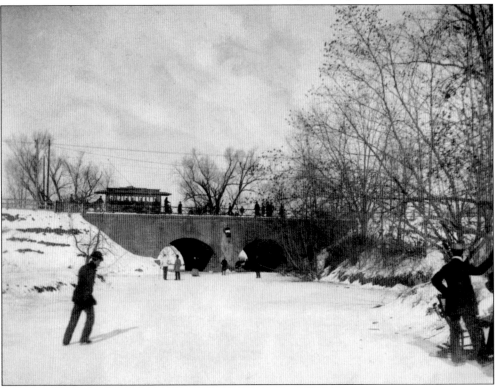

Hartford skaters who did not want to risk local ponds and streams used this downtown rink, built in 1869. The vast structure was also used for meetings and fairs, and in 1878 it was set up for gospel meetings. The revival preachers' approach did not appeal to Clemens, who said their criticism of a local clergyman who drank beer in public was "temperance rot."

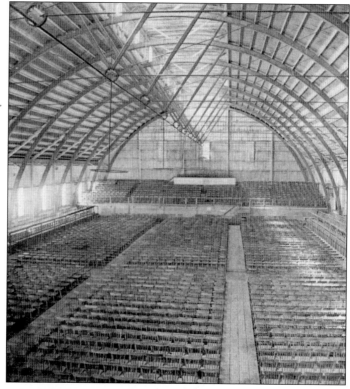

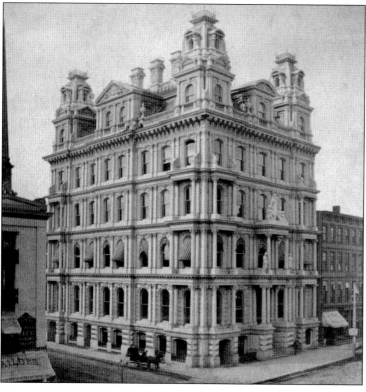

The city grew in leaps and bounds during the decade, and architecture mirrored its growth. The Connecticut Mutual Life Insurance Company built this wedding-cake headquarters at the corner of Main and Pearl Streets, typical of the Renaissance-inspired granite structures that were revising the look of the formerly wood-and-brick city.

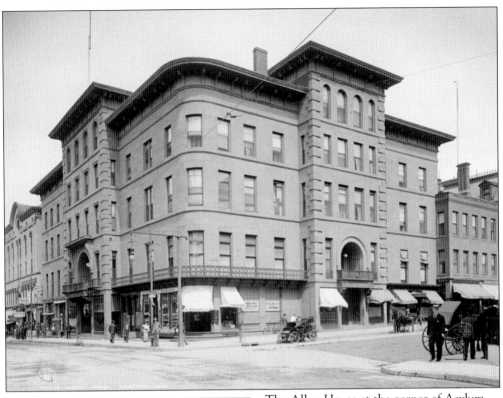

The Allyn House at the corner of Asylum and Trumbull Streets was the city's premier hotel during the Clemens era. It was next to Allyn Hall, a place for public events ranging from an 1865 memorial for Lincoln (just two years after John Wilkes Booth appeared in a play there), readings by Dickens, billiards tournaments, and the Beethoven Society's concerts.

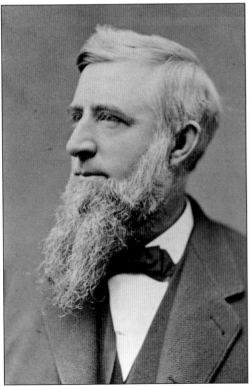

Henry C. Robinson, mayor of Hartford from 1872 to 1874, was part of Clemens's Friday Evening Club, a group of local men who met in the author's billiard room for cigars and political talk. Other members included Charles E. Perkins, Clemens's attorney and yet another Beecher relative; Edward M. Bunce, cashier of the Phoenix National Bank; and Franklin G. Whitmore, Clemens's Hartford business agent.

Since the founding of the republic, Hartford and New Haven had shared honors as the capital of Connecticut. But with state government expanding, this system proved unwieldy. Hartford offered land and $500,000 for a new capitol and won the votes needed. A somewhat tortured version of a design by Richard Upjohn was the result.

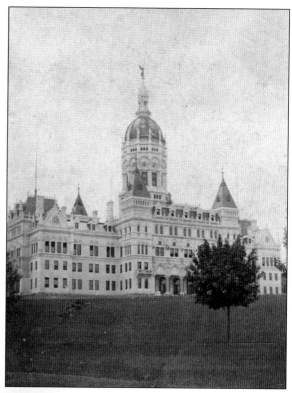

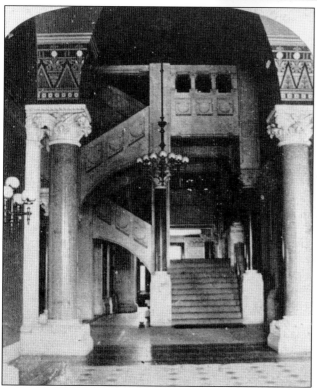

The new capitol was completed in 1878. The massive pillars in the interior were made from marble collected from four different New England states, and the building was a matter of civic and state pride. Clemens wrote one of his famously acerbic letters to the *Courant* suggesting that the skull and crossbones be flown from the new dome after an outbreak of malaria in the city.

At the end of the decade, Hartford celebrated a moment of civic and national pride: the moving of the Civil War battle flags from the old arsenal on North Main Street to the new capitol building. More than 100,000 veterans and others converged on the city on September 17, 1879, the anniversary of the Battle of Antietam, in which many state regiments took part.

Another civic ritual, portrayed in a *Scribner's* magazine article of the era, was the simple matter of shopping on the day before Thanksgiving in Statehouse Square, the area adjacent to what was now known as the Old Statehouse. The names and addresses of the businesses portrayed match up with city directories of the era, including the jewelry shop of Dwight H. Buell, who was to have a role in the Clemenses' financial downfall.

Clemens continued to contrive Hartford humor. The old Charter Oak, a symbol of freedom since the 1600s, had fallen in 1856. On his first visit, he had seen "a beautiful carved chair in the Senate Chamber" that was "made from Charter Oak," a local said. "He showed me a walking stick, a needlecase, a dog-collar, a three-legged stool, a boot-jack, a dinner-table, a ten-pen alley, a tooth-pick . . . 'Charter Oak.'"

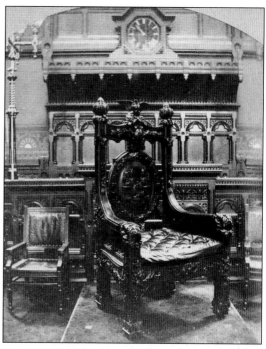

Clemens, a friend said, used to show visitors the city, taking them to the great covered bridge over the Connecticut River to East Hartford. Here, he would tell them, of course, that it had been built from the Charter Oak. The bridge had stood since 1818 and briefly outlasted Clemens in Hartford—it burned in 1895.

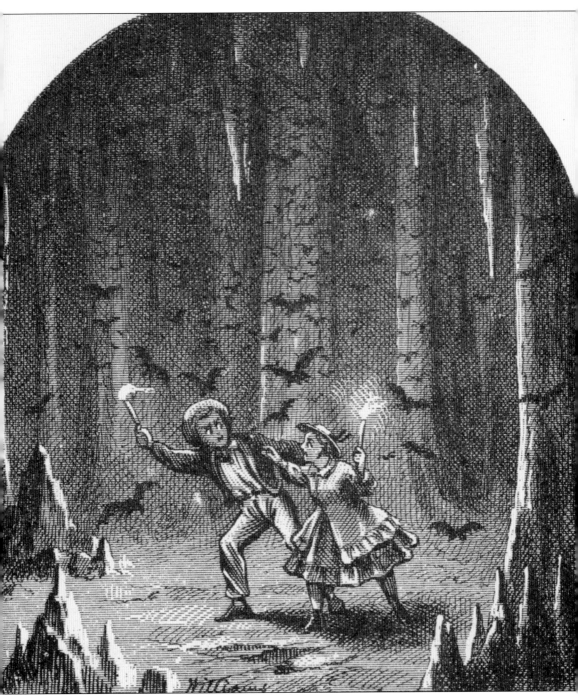

In 1876, Clemens's contemplation of his own youth and his early life along the Mississippi bore literary fruit in *The Adventures of Tom Sawyer*, an adventure story of youthful hijinks, hilarity, love, murder, and terror in St. Petersburg—which is, of course, Hannibal. Here, Tom and Becky Thatcher have gotten lost in McDougal's Cave: "Under the roof vast knots of bats had packed themselves together, thousands in a bunch; the lights disturbed the creatures and they came flocking down by hundreds, squeaking and darting furiously at the candles."

Patrick McAleer, who had joined the family as coachman at the time of the Clemenses' wedding, remained an important part of the family all during the Clemenses' Hartford tenure. He and his wife and seven children lived in a wing of the nearby barn, which matched the house in architectural style. Patrick "carried on his work systematically, competently, and without orders," wrote Clemens.

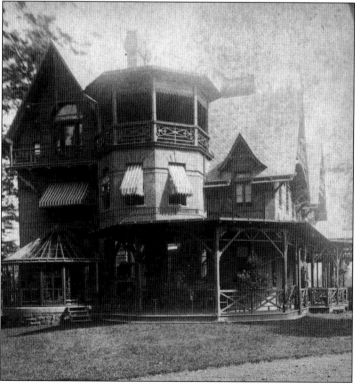

McAleer not only cared for the horses and carriages and "kept the bins and the hayloft full," but he also took a strong interest in the household flowers and plants. An unusual image of the house shows plants on the porch and the door into the conservatory. On a European trip, Clemens dreamed of that doorway—and of visiting neighbors passing through that door and "wrecking Patrick's flower pots with their dress skirts as they went."

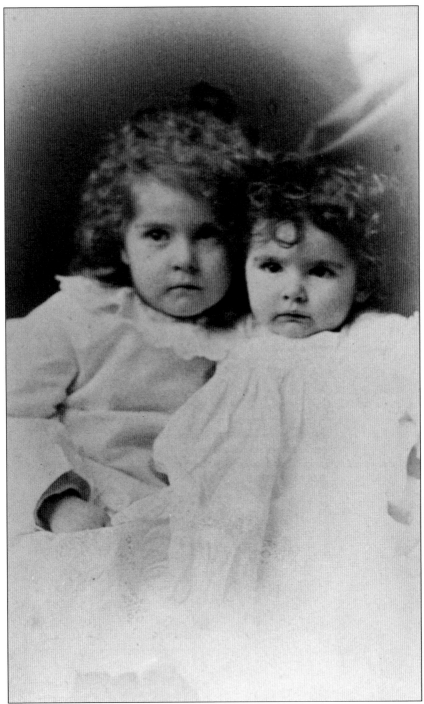

During the 1870s, Susy (left) and Clara Clemens lived what appears to be an idyllic life, adored by their parents and much loved by friends and servants. "Father never showed the least sign of being bored when my sister Susy and I clambered upon his knee, begging for a 'long' story," Clara recalled. "Father would start a story about the pictures on the wall . . . His power of invention led us into countries and among human figures that held us spellbound."

Olivia Clemens not only provided space and editorial critique for her husband's work, she also managed a large household—there were always six or seven full-time servants and any number of part-timers, and purchases to be made, along with an endless round of entertaining. "I told Mr. Clemens the other day that in this day women must be everything," she wrote to her mother in 1878.

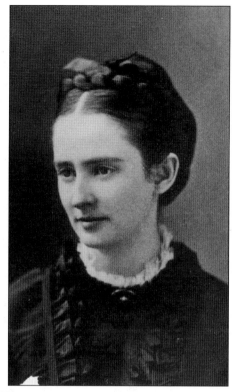

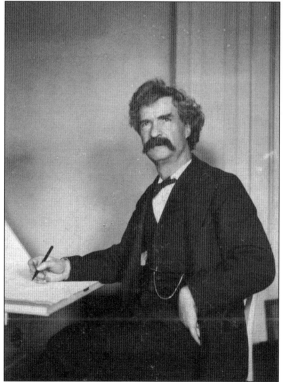

In the mid-1870s, Clemens was flush with success and frank as always about his likes and dislikes. "I like history, biography, travels, curious facts and strange happenings, & science. And I detest novels, poetry and theology." At the same time, as he tried out writing for the theater and after-dinner speechmaking, he took joy in his billiard room as refuge and workplace.

73

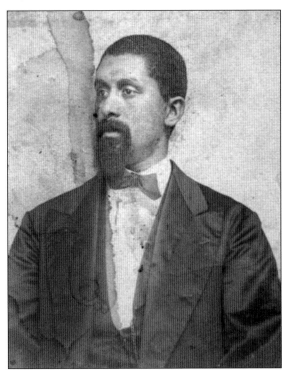

One of the great gaps in Twain biography is the lack of any image of George Griffin, whose role as Clemens butler and friend was deeply important to the family. Pictured here is an African American man in formal dress, of the right era, and of the right age, but unidentified. It is owned by a descendant of a family who knew Griffin. The intention is to add a human face to a community that was marginalized. (Courtesy of Elisabeth Petry.)

Griffin, a deacon of the Zion AME Church in Hartford, was also a significant politician, private banker, and bookmaker in the community. In his Hartford memoir, "A Family Sketch," Clemens says of Griffin: "He had a remarkably good head; his promise was good, his note was good . . . his word was worth par, when he was not protecting Mrs. Clemens or the family interests or furnishing information about a horse to a person he was purposing to get a bet out of."

Beset with "business responsibilities and annoyances, and the persecution of kindly letters from well-meaning strangers," Clemens left for Europe in April 1878. There, he said, he hoped to breathe "free air" and find a German village where no one knew him and write there. Before leaving, he contracted to write a second travel book. The result was *A Tramp Abroad* in 1880.

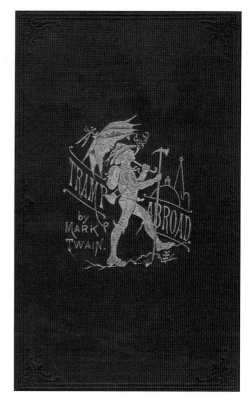

The family accompanied him on the 17-month trip, along with Livy's friend Clara Spaulding and nursemaid Rosina Hay to keep an eye on Susy and Clara. In Munich, six-year-old Susy sat for a portrait by a photographer in the studio of the late Franz Hanfstaengl, who had photographed composers Richard Wagner and Franz Liszt.

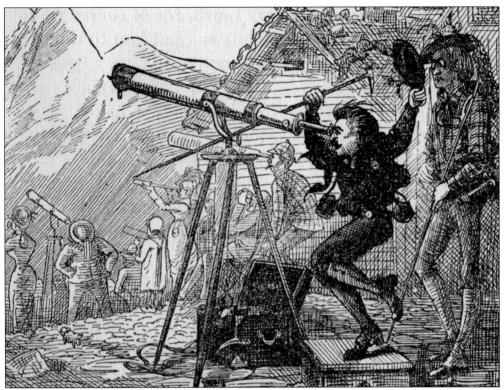

Clemens imported Twichell from Hartford to accompany him on what became the longest and liveliest section of *A Tramp Abroad*, set in the Black Forest and the Alps. Dubbed "Harris" in the book, the minister becomes a mildly pompous and comical foil. In this depiction of the pair climbing Mont Blanc vicariously via telescope, Harris is the overdressed character on the right.

Along with its literary purpose, the European trip was a voyage of acquisition for Livy Clemens, "an eager, indefatigable consumer," says scholar Kerry Driscoll. Among the many acquisitions shipped to Hartford was a music box, which, Driscoll says, provided Samuel Clemens agonies of anxiety about what music to install in it. The box displayed in the house today is a stand-in for the missing original.

Six

THE EIGHTIES

In 1880, "Dwight Buell, a jeweler, called at our house and was shown up to the billiard room—which was my study, and the game got more study than the other sciences," Clemens wrote in his *Autobiography* years later. Buell had supplied much of Livy's jewelry, and the Mark Twain House & Museum in Hartford today owns a pair of Clemens's cuff links in a Buell box.

"He wanted me to take stock in a type-setting machine." Clemens bought $2,000 worth, or about $40,000 in today's money. Clemens—who set type for printing as a boy—thought it was a sure thing. "I was always taking little chances like that," he writes, "and almost always losing by it, too."

He lost big. Over the following decade and more, he invested something like $200,000 into the Paige typesetter machine—$4 million in today's currency. A publishing venture that started off strong—with *Huckleberry Finn* and a real best seller, the memoirs of Gen. Ulysses S. Grant—eventually foundered.

In the early 1880s, the seeds were being sewn for family change—and for family tragedy. But the Clemenses lived a pleasant life of games of whist and carriage rides in Hartford. The decade began with the birth of a new daughter, Jean, and her elder sisters, Susy and Clara, began coming into their own as creative and dynamic young women. It was a decade, as Clemens said, of "servants, friends, visitors, books, dogs, cats, horses, cows, accidents, travel, joys, sorrows, lies, slanders, oppositions, persuasions, good & evil beguilements, treacheries, fidelities, the timeless & everlasting impact of character-forming exterior influences which begin their strenuous assault at our cradle & end only at our grave."

Hartford, meanwhile, grew apace. Electric light was introduced—not in the Clemens home—but notably in Armsmear, Elizabeth Colt's domain, and in civic "illuminations" for elections and other festivities. The telephone changed the way people talked to one another. (Clemens had one, and found the device infuriating—in part because he could hear only one half of the conversations he eavesdropped on.) In 1888, the first electric Hartford trolley put the first redundant pair of horses out to pasture. It was a time of transition, truly.

"I have been up all night helping to receive Miss Clemens," Samuel Clemens wrote to his friend Howells on July 26, 1880, "who arrived perfectly sound but with no more baggage than I had when I was on the river. I will go to bed, now—merely adding that mother & child are doing quite well, & the latter weighs about 7 pounds." Nursemaid Rosina Hay holds Jane Lampton Clemens —named for Clemens's mother, but ever known as Jean.

In 1880, the Clemenses hired a young woman from Elmira to work as a maid—Katy Leary, the daughter of Irish immigrants, who became a steadfast figure in the household through the Hartford years and long after. "Katy was a potent influence, all over the premises," Clemens said. In turn, she dictated a memoir in the 1920s recalling "the wonderful life I had with them."

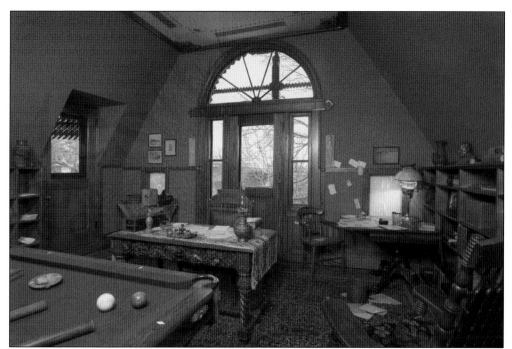

It was that same year that the Hartford jeweler Buell introduced Clemens to a hot prospect—the mechanical typesetter—in his billiard room. Despite his stock purchase, he was skeptical, "for I knew all about type-setting by practical experience," but on a visit to the factory, he said, "the performance I witnessed did most thoroughly amaze me."

"Here was a machine that was actually setting type," said Clemens, "and doing it with swiftness and accuracy, too." It was the beginning of a long decade of investment, hopes, and disappointments. In *Typographical Printing-Surfaces: The Technology and Mechanism of Their Production*, Lucien Alphonse Legros and John Cameron Grant comment on the whole sad story: "It would be fruitless and tedious history to detail all the delays that followed due to limited capital and other causes."

In March 1881, Clemens wrote to his sister Pamela Moffett: "In June we shall tear out the reception room to make the front hall bigger; and at the same time the decorators will decorate the walls and ceiling of our whole lower floor." In May, he approached Herbert M. Lawrence, a decorator whose work he and Livy liked. Lawrence was unavailable but recommended Louis Comfort Tiffany (pictured).

Tiffany, a scion of the famed New York jewelry family, had organized a group of decorators called Associated Artists, with painter Samuel Colman in charge of colors and patterns for walls and ceilings, artist Lockwood de Forest providing carved woodwork and furniture, and Candace Wheeler creating textiles and embroidery. The delicate stenciling in the house today is a restoration of some of the group's work.

The stenciling extends to the ceiling, whose compartmented segments give the impression of a Middle Eastern mosque. The first floor of the house is permeated with design motifs from Morocco, India, Japan, China, and Turkey. The mother-of-pearl sheen of the stenciled pattern is intended to provide a glittering majesty when illuminated by flickering gas wall sconces.

The redecorated front hall uses the red-and-black patterns in the stenciling to draw the eye from the walls and up the grand staircases. While the work was being done, the Clemenses had to camp out on the second floor again. "O never revamp a house," Clemens writes. "Leave it just as it was, & then you can economise in profanity."

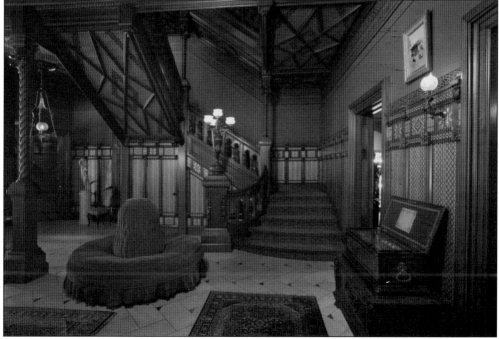

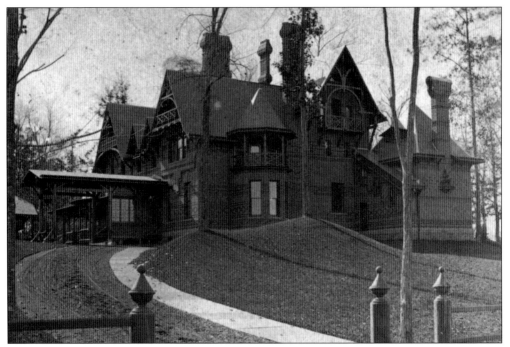

Redecoration was not the only work to be done. The house's kitchen wing faced Farmington Avenue with a blank, windowless stare. Clemens did not like the price tag submitted for the work by Hartford builder James Garvie: "It can't cost $6,000 to build that 20 foot coop & paint the house &c." Garvie had built the whole Warner house (page 42) for $13,000, he said.

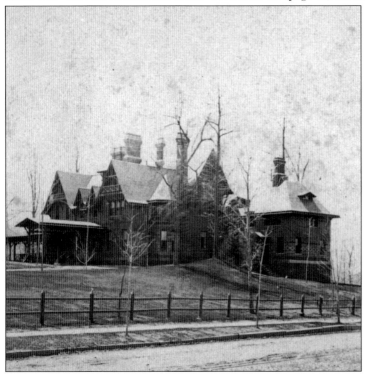

After the 20-foot coop was complete, the denizens of the Clemens kitchen had a better view of Farmington Avenue, and neighbors were provided a friendlier view of the house. When Clemens was asked why the service wing of the house faced the avenue instead of the entry or some other grander feature, he said it was "so the servants can see the circus go by without running out into the front yard."

At the same time the rebuilding and redecorating was going on in Hartford, Clemens published an unusual work for those assuming that *The Adventures of Tom Sawyer* would set the tone of his novels for young people. *The Prince and the Pauper* is a tale of medieval England in which a poor boy and Prince Edward, son of Henry the Eighth, switch places, with comic, tragic, and socially satirical results. His family loved it.

"LET HIM IN!"

In mid-decade, the family gathered to be photographed on the porch in summer. Clara, 10 or 11, stands with her arm around her father. Jean, four or five, is between her parents, and Susy, 12 or 13, looks intently toward the camera from her seat.

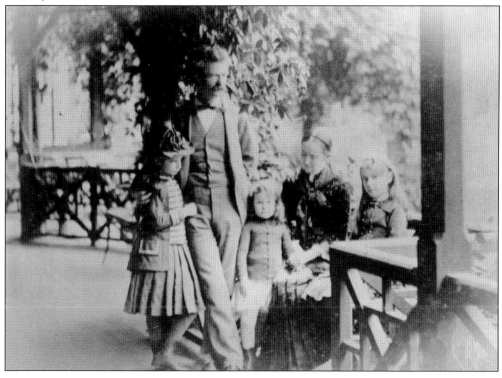

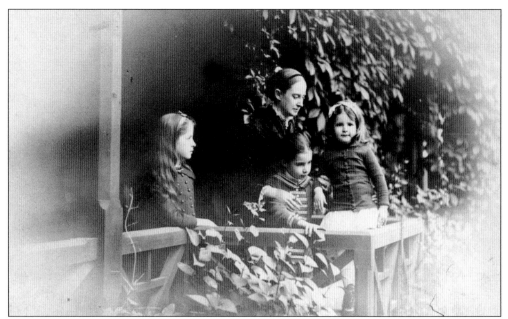

Mother and children regroup a little farther down the porch, surrounded by the Virginia creeper vines that provided shade around the windows in summer, then dropped their leaves in winter to let in the sun. Around this time, Livy, Susy, and Clara were listening to Clemens read *Adventures of Huckleberry Finn* in manuscript. Livy "expergated" Huck's tale, Susy wrote, sometimes to the girls' horror.

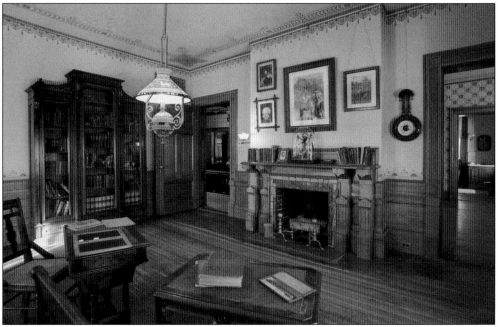

In 1880, Clemens abandoned his second-floor study, which became a schoolroom. In a memoir, Clara notes the theatricals the girls put on in the room were more fun than their lessons. Her father writes, "The chief characters were always a couple of queens. "Jean had one function—only one. She sat at a little table about a foot high and drafted death warrants for the queens to sign."

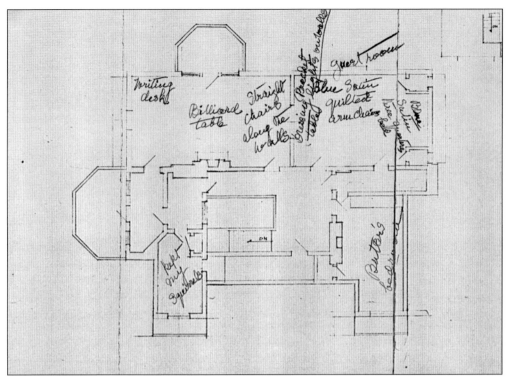

Many years later, Clara provided the restorers of Mark Twain's house with her jottings on a plan of the third floor. On the lower left is a small room labeled "kept my squirrels." She and Susy tried to tame wild squirrels, then turned the room into a prison for a pirate, then, "his place was filled by St. Francis, who, we hoped, would tame the squirrels."

In 1883, *Life on the Mississippi* was published—a lively account of Clemens's piloting days, combined with heavy dollops of history and travel narrative. Clemens returned to the Mississippi for the book, accompanied by his publisher, James R. Osgood. Work on the book helped with the novel he was beginning to complete about "Tom Sawyer's comrade," Huckleberry Finn.

"SCARED TO DEATH."

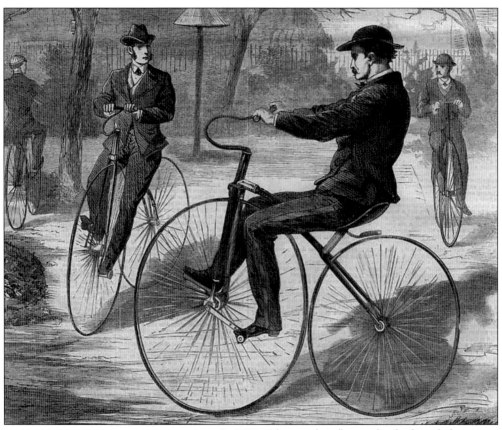

In 1884, Clemens briefly caught the bicycle bug, urged on by his friend Twichell. Clemens's essay "Taming the Bicycle" provides a hilarious view of his lessons. "I had no gift in that direction and was never able to stay on mine long enough to get any satisfactory view of the planet," he writes. (Courtesy of the Library of Congress.)

Clemens was a Republican, but during the presidential year of 1884 word came—via speaking tube (pictured) in the billiard room, where Clemens and his friends were playing—that the corrupt James G. Blaine had been chosen as the party's candidate. The butler Griffin relayed the news from the kitchen after receiving it by telephone from party headquarters.

"The butts of the billiard cues came down on the floor with a bump," Clemens writes. All the assembled group were Republicans, and most ultimately had to support Blaine, but Clemens would not. "No party held the privilege of dictating to me how to vote," he writes. The independent stand he took in supporting the Democrat Grover Cleveland (seen here) cost him friends in Hartford.

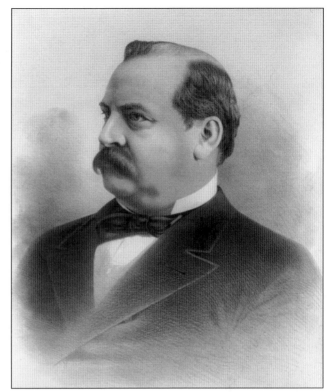

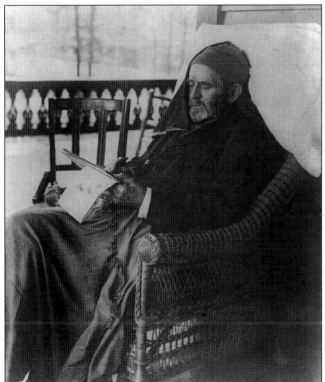

In May 1884, Clemens decided to start his own publishing house, contracting with the ailing former general and president Ulysses S. Grant (pictured) to publish his memoirs. Despite his fame, Grant was in financial trouble, and Clemens's efforts ensured that the work—considered a classic of military history—would provide income. It did, but the income went to Grant's widow, Julia; her royalty check of $250,000 was the largest ever paid up to that time, but the old general had died just after finishing the book.

In the mid-1880s, his hair graying from auburn, Clemens was still optimistic about his and his family's financial prospects. In the words of biographer Justin Kaplan, "Clemens' brave world was still new, he had not yet been betrayed by the machine, nor had he composed his sad and sardonic farewells to what he called 'the drive and push and rush and struggle of the raging, tearing, booming nineteenth century.'"

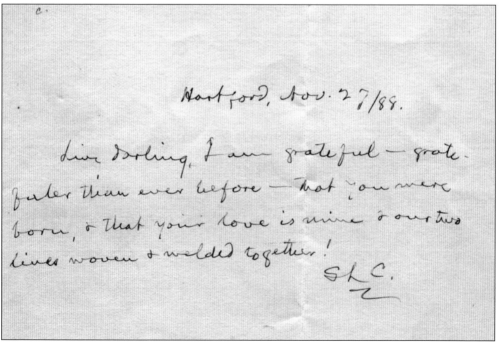

His love for Livy persisted during good times and bad, in companionship and while he was away, when he once wrote, "How measureless & lonesome the time since I have seen you, my dearest!" On her birthday in 1888, he penned this note.

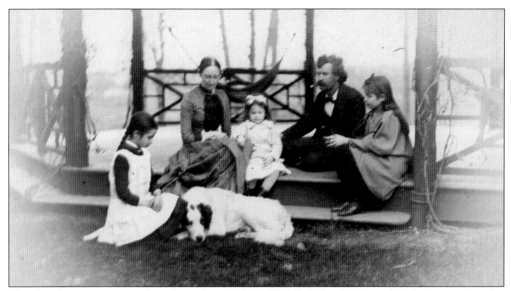

The family once again gathered on the porch in Hartford for photographs, this time after the Virginia creeper's leaves had fallen. A visiting in-law remembered convivial gatherings in the library during this period: "The fine, smooth outlines of the head of our hostess came out with wonderful clearness against the dark background and in perfect keeping with the flowers and filtered sunshine of the little conservatory."

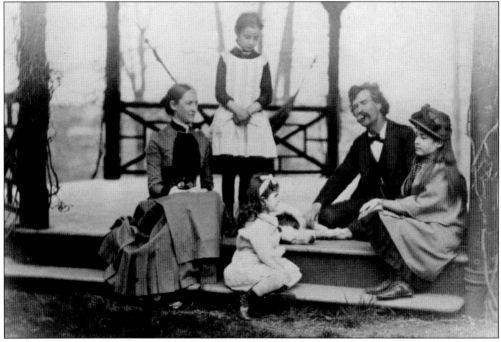

The family regroups for another Hartford shot: from left to right are Livy, Clara, Jean, Samuel, and Susy. The dog, Flash, reclines on the "ombra," a long extension of the home's porch. From a lecture tour, Clemens wrote to Jean: "I often think of you and your sisters. Whenever I see a sweet child in the trains or in the hotel, Jean comes before my eyes and I cannot see the other child for the tears." (Courtesy of the Mark Twain Papers and Project, Berkeley.)

In her pinafore, Clara poses with Flash and her pet calf, Jumbo, near the porte-cochere of the Hartford house. Coachman Patrick McAleer convinced the little girl that if she "curried the calf every morning and threw a saddle and bridle on him he would turn into a horse." When she tried to ride, though, "I was hurled into the nearest bush before I could even give thanks for my new pony."

Clara, as she put it, "retreated to the nursery" after a second ejection from Jumbo's back, until she heard that the calf had been sold. "I raised such a hullabaloo that my screams reached even my father's study," she writes. "He came running down to snatch me from danger." The family repurchased Jumbo the same day.

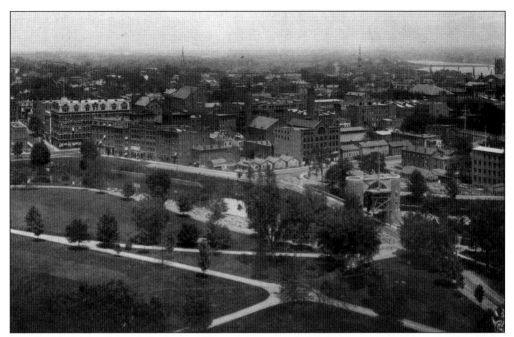

Hartford was growing rapidly in the 1880s, and in this view from the capitol dome it is possible to see (at the lower right) the construction of the Soldiers and Sailors Memorial Arch. This massive memorial to Hartford's Civil War role was dedicated on September 17, 1886—the same day as the battle-flag ceremony seven years before, the anniversary of Antietam.

Architect George Keller, whom Clemens knew, designed the arch, whose dedication again brought thousands of attendees to the city to honor the 4,000 from Hartford who participated in the war and the 400 who died. Constructed of brownstone quarried from nearby Portland, Connecticut, and bearing statues and friezes commemorating the war, it still stands as a city landmark.

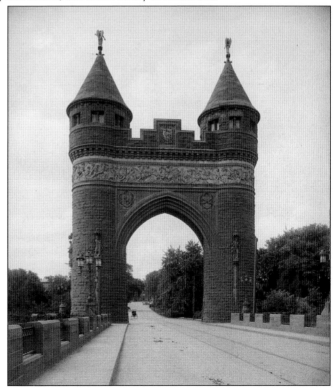

The blizzard of 1888 lasted from March 12 to 14 and dropped more than 50 inches of snow on the Northeast, with winds of 60 and 70 miles per hour. Much photographed was this "snow tunnel" on Clinton Street in Hartford. Clemens was stranded in the Murray Hill Hotel in New York, "out of wife, out of children, out of line, and out of cigars, out of every blamed thing in the world that I've any use for."

With the snows dispersed, workers at Brown Thompson & Co., a furniture dealer that had taken over the 1875 Cheney Block building designed by H.H. Richardson, pose proudly in front of their place of work. The store, along with nearby G. Fox and Sage Allen stores, later became a mainstay of the downtown department store district. "Busier than Brown Thompson" became a Hartford expression.

Starting in November 1884 in New Haven, Clemens traveled the country with fellow lecturer George W. Cable, author of Louisiana novels such as *Old Creole Days* and *The Grandissimes*. The four-month journey was a difficult one, with Clemens impatient with his traveling companion's piety and distracted by publishing preparations for *Huckleberry Finn*. The book was to come out from Clemens's new publishing venture, Charles W. Webster & Co.

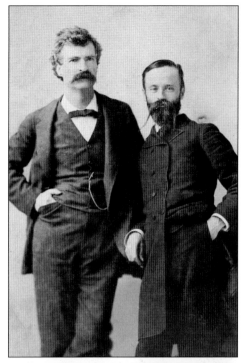

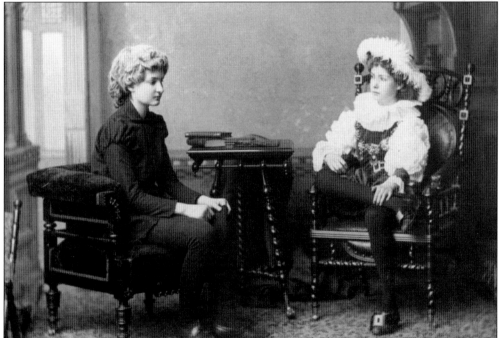

When Clemens returned from his journey with Cable in early 1885, Livy had organized a surprise for him: a dramatization of *The Prince and the Pauper* performed in the nearby Warner house. In this studio portrait, Susy Clemens is the Prince (right), and George and Lilly Warner's daughter Margaret (left), is Tom Canty, the pauper. "It was a charming surprise, and to me, a moving one," said Clemens.

Adventures of Huckleberry Finn was published first in England, in late 1884, and in the United States early the next year. Its superbly told tale of a young abused boy and the escaped slave Jim, who together create a free world on a river raft, has been acclaimed by critics ever since. In 1953, to cite one of innumerable examples, Leo Marx opined that "the truly profound meanings of the novel are generated by the impingement of the actual world of slavery, feuds, lynching, murder, and a spurious Christianity upon the ideal of the raft."

Among the luminaries who visited the Hartford house in the 1880s was Henry Stanley, the *New York Herald* reporter who searched for and found the missing Scottish missionary and explorer Dr. David Livingstone—making the greeting "Dr. Livingstone, I presume?" famous. "He seemed modest, intelligent, strong, honest," his fellow dinner guest, Twichell, writes. "His style of narrative [was] fascinating, dramatic, entertaining and thrilling to the last degree."

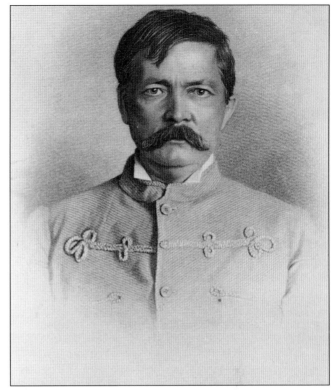

Grace King was another guest—a writer on Louisiana subjects and scenes, an unreconstructed Southerner who left behind vivid descriptions of the Hartford house and what it was like to talk to Samuel Clemens: "He is quick to catch your idea—and nice to it, after he catches it. He does not impose his opinions, at least on me he did not—and he listens—at least to me—with attention. His spirits rise easily—his fun is never asleep—at a wink he is alert."

On hill beside Mark Twains house.

The Prince and the Pauper became a stage play, and the actress who played both prince and pauper, eight-year-old Elsie Leslie, came to visit in 1890. Susy, Clara, and Jean were impressed not only that they had a real actress staying in their house but also that she was delighted to play with them like any other girl—as here, where, on March 4, she and Jean, nine years old, slid on toboggans down the truly frightening steep slope behind the Clemens home.

The girls refined their own dramatic skills, especially the literary Susy, who had commenced a biography of her father when she was 13. The girls and two friends enacted her drama *A Love Chase* in the drawing room in 1889. The play is full of allegorical figures and, on the right, a shepherd boy, played by their friend Fanny Freese. The rest of the cast, from left, are Clara Clemens, Margaret Warner, Jean Clemens, and Susy Clemens.

Susy takes a curtain call for *A Love Chase*. Years later, Clemens remembered the moment in a rare foray into poetry, informed by grief: "Slowly, at last, the curtain fell. / Before us there she stood, all wreathed and draped / In roses pearled with dew—so sweet, so glad, / So radiant!—and flung us kisses through the storm / Of praise that crowned her triumph."

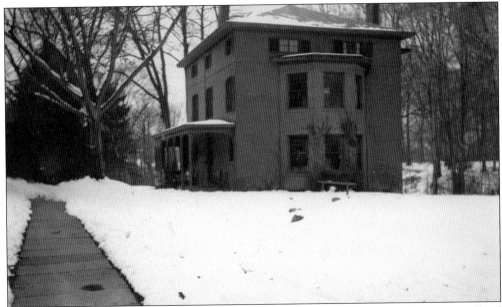

Toward the end of the decade, Clemens retreated to his friend Twichell's house on Woodland Street to finish a story of time travel, in which a foreman at the Colt Armory in Hartford, knocked on the head during an altercation, wakes up in King Arthur's Britain. On first seeing Camelot, he asks, "Bridgeport?"

"I SAW HE MEANT BUSINESS."

A *Connecticut Yankee in King Arthur's Court* was a bitter satire on the Gilded Age, whose worst traits are mirrored in the excesses of the royalty, priests, and knights of Arthur's time. The story is funny—there is a baseball game among the Knights of the Round Table—but it ends in an apocalyptic scene of destruction and death.

Seven

DEPARTURES

As the 1890s began, the Clemenses found themselves in poor financial straits, with the Paige typesetter continuing to eat up money and his publishing company, after the success of *Huckleberry Finn* and the blockbuster success of Grant's *Memoirs*, foundering on an unsuccessful biography of Pope Leo XIII. An economic slump in 1890 made things worse. The family suffered from ill health; Susy was homesick at Bryn Mawr College, and in the fall of 1890 both Sam's and Livy's mothers died. Maintaining the Hartford house was a bottomless expense. "I wish there was some way to change our manner of living but that seems next to impossible unless we sell our house," Livy writes.

They did not sell the house, but they moved out and went to live in Europe—both as an economy and to provide a fertile literary field for Clemens's work. The plan was to return as soon as possible, but the decision was like "a funeral of several days," Livy's sister writes.

It was the beginning of two decades that were to see real funerals—too many. The European sojourn led to one extraordinary work by Clemens—a drama of twins and race prejudice called *The Tragedy of Pudd'nhead Wilson*, then the less-regarded *Joan of Arc*, and finally a plan to go around the world and produce another travel book. Just as the long journey ended, tragedy struck—Susy died of spinal meningitis on a visit to Hartford. "It is not the city of Hartford; it is the city of Heartbreak," he writes his friend Twichell; the travel book, *Following the Equator*, was written in grief. The Hartford house was sold in 1903; Livy died in Florence in 1904.

Clemens had recouped his finances and in his last years built a new home in Redding, Connecticut, about 60 miles west of Hartford. He stayed in touch with old friends and made rare visits. In a final blow, his daughter Jean died on Christmas Eve 1909. Clemens followed her four months later. "The thought of his departure hence was not unwelcome to him," writes his old friend Twichell.

In 1890, the Clemenses visited Candace Wheeler, a famed American interior decorator who had been with Tiffany's Associated Artists when they redecorated the Hartford house in 1881. Wheeler had established a community of massive "cottages" in New York State's Catskill Mountains for the use of people in the arts. Enjoying the break from Hartford worries—with Susy just having

gotten good news of her admission to Bryn Mawr—father and daughter hammed it up as Hero and Leander from Greek myth. Leander swam the Hellespont to visit his priestess lover Hero; Clemens donned a bonnet and thought it would have been prudent for Leander to wear a hot water bottle.

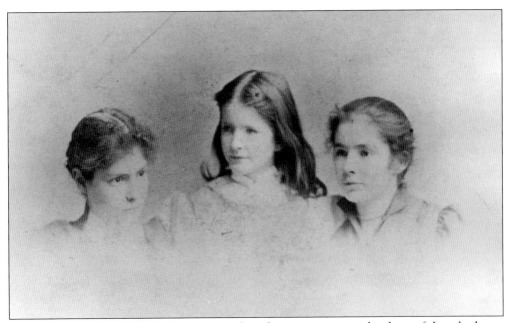

By the 1890s, even Jean (center) was approaching her teenage years; the three of them had very different personalities. Clara (right)—as evidenced by the incident with the calf—could be explosive, emotional, and risk-taking. Susy (left) was subdued, literary, and musical. Jean seemed to be happy wherever she could find animals to visit.

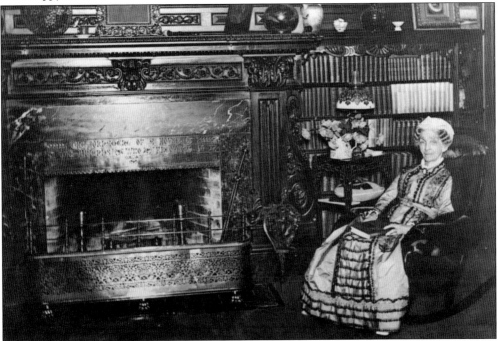

Olivia Lewis Langdon, Livy's mother, was a frequent visitor to the Hartford house, as well as a financial benefactor. Traveling from Elmira, she would stay several winter months in what Clemens called "Ma's bedroom" and was unfailingly generous and attentive to the children. Her death in 1890, like the death of Jane Lampton Clemens just a month before, was devastating.

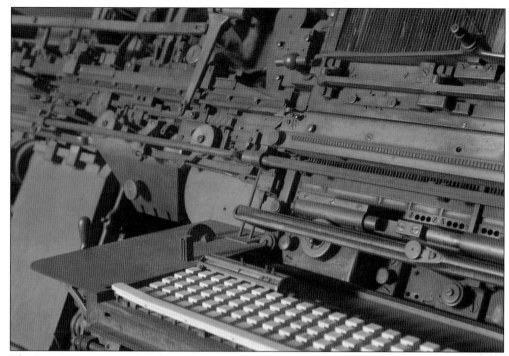

The Paige typesetter remained a malevolent force in the family, draining their finances, as Clemens remained optimistic about its prospects. It was not until 1894—the same year his publishing company declared bankruptcy—that it became clear that the future of mechanical typesetting lay with rival Otto Mergenthaler's linotype machine.

The Clemenses left Hartford as it was changing rapidly, nearly double the size of the small brick-and-wood city Clemens first saw and full of imposing new buildings. Pictured here around 1890, elephants parade down Main Street. If they had passed down Farmington Avenue after spring 1891, there would have been no servants to run to the kitchen wing's windows to see them.

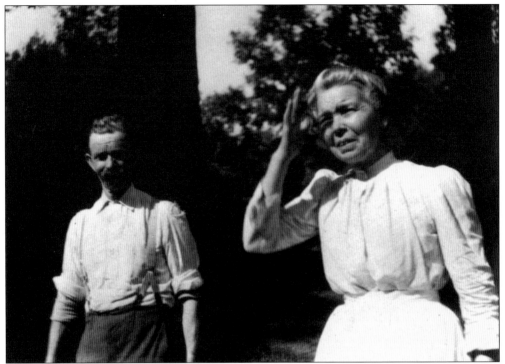

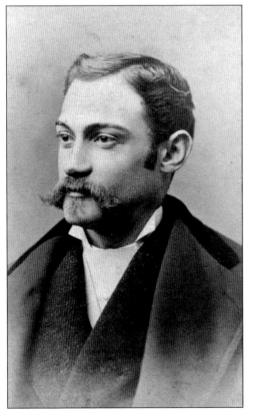

After the Hartford house was rented in the mid-1890s, John O'Neil and his wife, Ellen, who lived on nearby Forest Street, moved into the carriage house and took over as caretakers. On a return visit to the United States, Clemens visited the house: "I was seized with a furious desire to have us all in this house again and right away, and never go outside the grounds again forever."

Hartford business was left in the hands of Franklin G. Whitmore, who owned a real estate office and had been Clemens's business agent since the mid-1880s. When in the very early 1900s the Clemenses decided to sell the home, the author's attitude had changed considerably. "For the Lord Jesus H. Christ's sake sell—or rent—that God damned house," he writes.

Teenagers Susy and Clara ride on a horse cart during the 1890s. When the sisters got to Europe, they often found their behavior circumscribed by their parents, especially when it came to associations with young men. And life with father was not easy. Susy in Paris wrote to Clara in Berlin: "I have to go down to breakfast now, and I don't enjoy this one bit, altho Papa hasn't stormed yet."

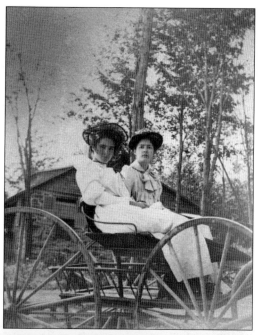

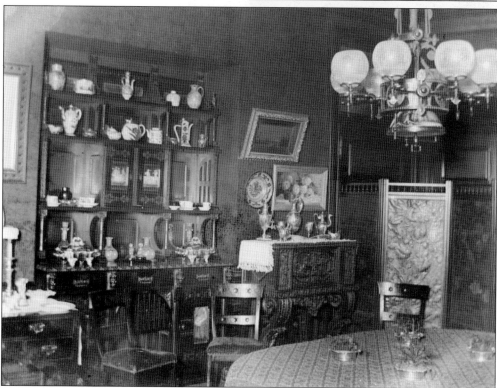

The house rented, some of the interior was recorded by a young photographer who captured the table, great sideboard, and other furnishings in the dining room in the 1890s. These rare shots aided the restoration of the house in the following century. The doors behind the screens led to the servants' domains—not restored until the early years of the century after that.

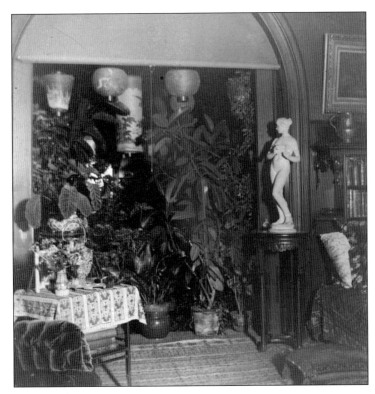

The same photographer recorded the conservatory, with its statue of Eve by the sculptor Karl Gerhardt observing the greenery and Japanese lanterns. The Clemenses had sponsored a Paris art education for Gerhardt, chief mechanic at the Pratt & Whitney plant. His advocate in approaching Clemens was his wife, Harriet, who also posed for the statue.

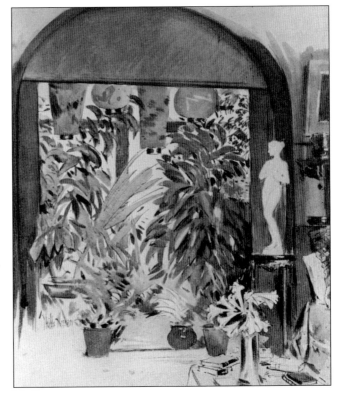

In what seems almost certainly a watercolor based on the photograph above, the American impressionist painter Childe Hassam has provided his own rendition of the conservatory and the statue of Eve to illustrate an article on Clemens in *Harper's New Monthly Magazine* in 1896. The article was by Clemens's close friend Joseph Twichell.

In his *Harper's* story, Twichell writes more of Clemens's personal biography and literary achievements than of his life in Hartford, but Hassam reveled in views of the house – as in this evocative portrait of the house in winter. The artist was very much in tune with his times, as illustration evolved from strict line drawings to displays of brushwork.

THE DECK, HARTFORD.

Twichell assumed when this article came out that his friend might return at any time. He writes to Clemens, "When are the Clemenses coming home?" The ombra (sometimes called "the quarter-deck") portrayed by Hassam evokes the conversations Twichell longed to have with Clemens: "Let the spirit of utterance be quickened in him, and you have him at his best," he writes in *Harper's*.

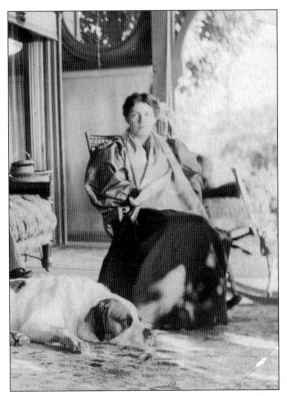

While Samuel, Livy, and Clara Clemens circled the earth via New Zealand, Australia, India, and South Africa, Susy stayed at home on another porch, this one at the home of her aunt and uncle Susan and Theodore Crane in Elmira. In 1896, she visited Hartford, spending days in the old house. "The house is beautiful and the books are beautiful and the sky is beautiful," she writes.

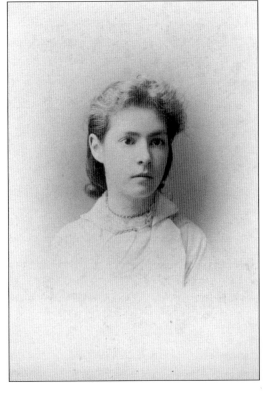

Word came to England that Susy had fallen ill in Hartford, and her mother and sister took the first boat back. When Clemens got the telegram that told him that Susy had died, "I was not dreaming of it. It seemed to make me reel." Long ago, a friend had described her eyes: "Oh, I wish I could convey . . . the expression in those lovely eyes of Susy Clemens! . . . They were large, lustrous, animated, expectant, alert."

After mourning and more travels, the Clemenses returned to America—and decided that the parting from Hartford was permanent. Here, they take refuge in an Adirondack "camp" in 1902; they were increasingly worried about Jean, who had been diagnosed with epilepsy, and Livy's own health soon declined.

Clemens visited his old hometown of Hannibal for the last time in 1902, on his way to receive an honorary degree at the University of Missouri. He said of his boyhood home, "It all seems so small to me. I suppose if I should come back here ten years from now it would be the size of a bird-house." A boyhood friend commented on the locals: "Same damned fools, Sam."

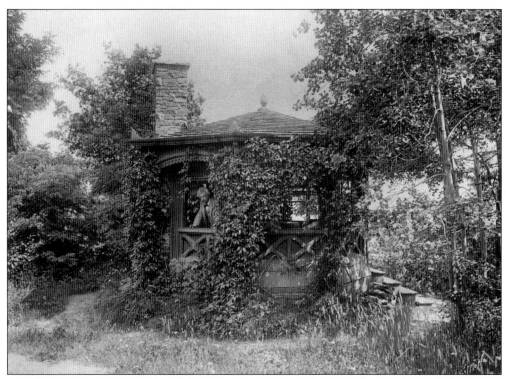

In 1903, the couple made their last trip together to Elmira, where Clemens examined the now-overgrown study where he had worked on so many books as a young man. Livy rode in a carriage, went on wheelchair outings, resumed household duties, and seemed better. Doctors recommended that she go to Europe for her health, and the couple left in October.

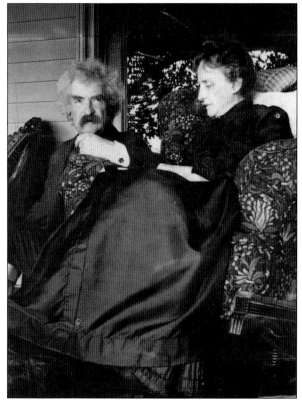

In June 1904, Livy Clemens died in Florence. Three days later, Clemens wrote to Twichell in Hartford: "Many a time, these months, she said she wanted a *home*—a house of her own, that she was tired & wanted rest, & could not rest & be in comfort & peace while she was homeless . . . It was a most merciful death & I was & am full of gratitude that it came without warning & was preceded by no fear."

Clemens returned to the United States and leased a house in New York; here and in summer homes, and finally in his new home in Redding, Connecticut, he wrote and played billiards. He regarded it as therapy. He wrote Jean while visiting a friend in Massachusetts: "After luncheon here I began to play billiards & kept it up until a quarter past 2 this morning."

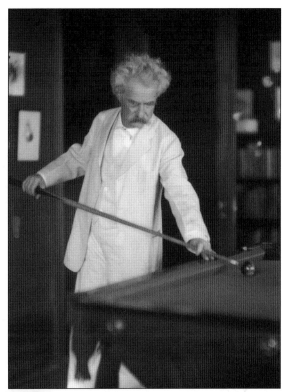

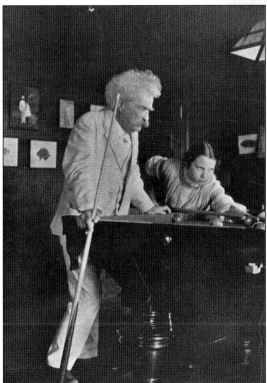

Louise Paine, the daughter of Clemens's official biographer, Albert Bigelow Paine, aims a shot. Clemens was concerned that his life be a known one and spent a good deal of his final years dictating his autobiography to stenographers. The mass of material that thus accumulated has only recently been put into an authoritative document, published in three massive volumes by the Mark Twain Papers and Project.

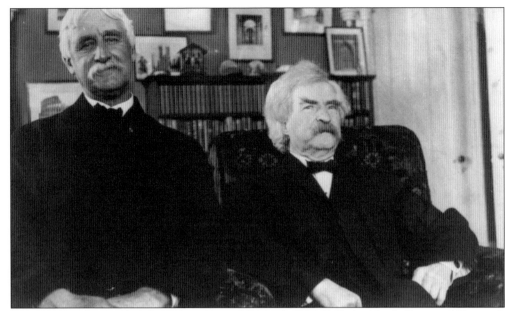

Clemens stayed in touch with old friends, notably Twichell. In 1905, the Twichells visited Clemens's Fifth Avenue house in New York, where Jean Clemens took a photograph of the pair. The two men wrangled over politics and religion but remained close. After one letter excoriating the minister's views, Clemens closed it: "Joe, the whole tribe shout love to you and yours."

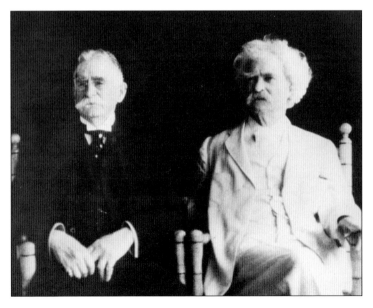

Another close friend during these last years was Henry H. Rogers, a Standard Oil executive who befriended Clemens during his financial troubles, took over his investments, and made them pay. He was a constant billiards companion. According to a well-worn tale, when Clemens was challenged for being friendly with a man whose money was "tainted," he replied, "Right, Madame! T'aint yours and t'aint mine!"

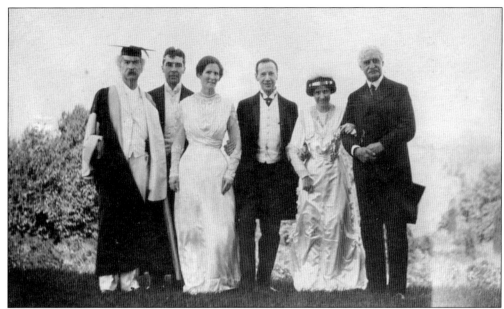

In 1909, Clemens was living in Stormfield, his new home in Redding, Connecticut, and Clara (second from right) decided it was just the place for her October wedding to Ossip Gabrilowitsch (third from right), a Russian-born pianist, conductor, and composer. She lined up the old pastor Twichell (far right) for the occasion, and Clemens wore the academic gown that he received when Oxford University gave him an honorary degree. Others are nephew Jervis Langdon (second from left) and Jean Clemens.

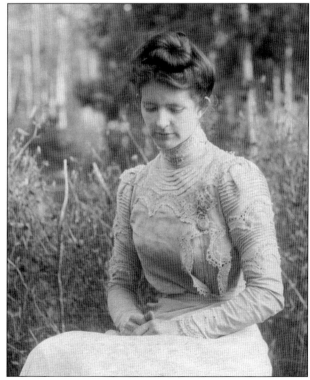

Jean, after going through treatments and rest cures for epilepsy that isolated her from her family, had finally come to live with her father in Redding in April 1909. There she rode on horseback, donated to the SPCA, helped Clemens found a local library, and supervised the author's household. On Christmas Eve came a blow—after decorating, Jean suffered a seizure and died. "How poor I am," writes Clemens, "who was once so rich!"

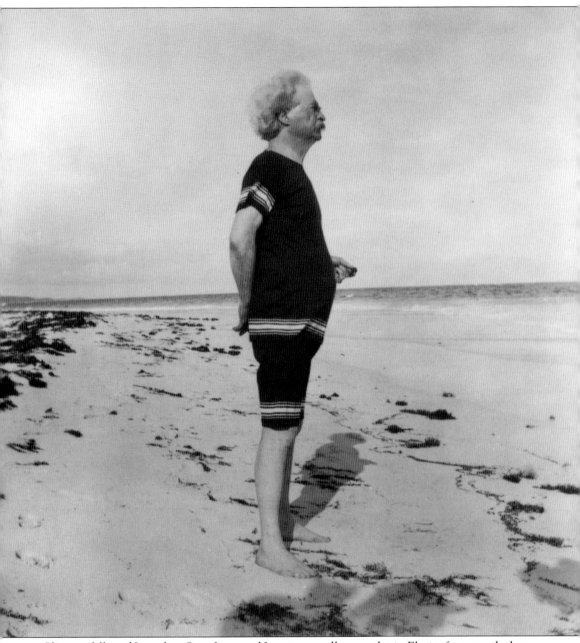

Clemens followed Langdon, Susy, Livy, and Jean to a small grave plot in Elmira four months later. In his last years, he had discovered the "Islands of the Blest," Bermuda, where he was photographed looking out to sea. He was far from his Hartford home and had indeed said that "the country home I need is a cemetery." He had fallen heir, as he said in another weary moment, "to the best thing in the treasury of life, which is death."

Eight

A Home Restored

Katharine Seymour Day was 25 when her parents rented the Clemens house in 1895, during the time when the Clemenses were still expected to return. "It was a charming, delightful, artistic house to live in," she writes, "there was still the glory over the western sunsets over the meadow, trees and Little River, although already the neighborhood was far less rural than twenty years before when the house was built."

By the time of Samuel Clemens's death in 1910, the city had grown more, its population nearly doubling from the time of the Days' rental, nearing 100,000. Farmington Avenue was still a strong address, though the old mansions were receding as apartment houses were built. The Clemens home had been bought by an insurance executive who ultimately leased the house to a boys' school. From there it passed to a real estate investor who planned to raze it, creating a scare and a campaign by a local artist to save the building. It was instead converted into apartments, but in the late 1920s came another demolition scare.

This time it was Day herself who stepped in, organizing the Friends of Hartford, which raised funds to buy the house and make it part of a complex honoring the literary heritage of Nook Farm—of which Day herself was a scion as the grand-niece of Harriet Beecher Stowe. The Mark Twain Memorial and Library Commission bought the house and leased the ground floor to the city as a library branch.

In the 1950s and 1960s, the memorial turned to a new tack—restoration. The library departed, apartments that remained on the upper floors were phased out, and a tremendous work of meticulous research, investigation, and craftsmanship followed. In ensuing decades, the restoration was continued, refined, revised, and debated. A visitor center was built, its modern bulk lodged in a hillside behind the house to keep the old crazy brick mansion the Clemens family loved, in the city they loved, still in an unrivaled and prominent position above Farmington Avenue.

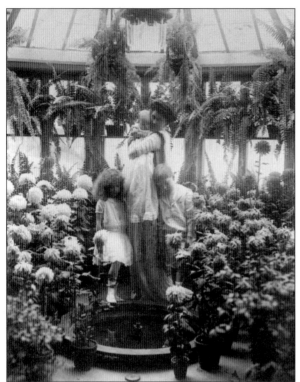

In 1903, Richard Bissell, president of the Hartford Fire Insurance Company, moved into the house with his wife, Marie, shown here in the conservatory holding infant Richard, with daughter Anne-Caroline and son William on either side. Richard Jr. remembered that his mother "updated the interior to eliminate its Victorian darkness," though as a child he loved the "queer little balconies and curiously shaped closets under the eaves."

The Bissells moved to suburban Farmington and leased the house to the Kingswood School for boys. The drawing room became a library, the library a classroom, and the carriage house a gymnasium. The baseball team poses for a portrait on the hillside below the conservatory sometime between 1916 and 1920.

In the library classroom, Marie Bissell's grass cloth wallpaper can be seen over the former bookshelves, whose frames only remain. When new owners converted the rooms of the house into apartments, even the frames of the bookshelves were removed; photographs and one fragment provided clues for the eventual restoration.

When in 1923 artist Nunzio Vayana led a drive to save the building, a young editor of the *Hartford Courant*, Emile Gauvreau, joined the campaign. His publisher, Charles Hopkins Clark (pictured), disapproved. He been a friend of Clemens's, but disapproved of the author's opposition to Blaine back in 1884. "He and his crony, Holy Joe Twichell, voted for Cleveland after we had come out for Blaine," Gauvreau quoted Clark as saying.

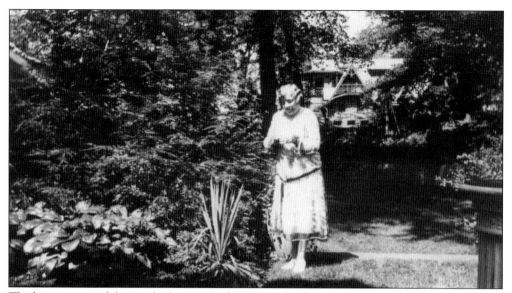

The house survived, but in the late 1920s there was another spate of worry about its future. This time, its champion was Katharine Seymour Day, granddaughter of Isabella Beecher Hooker and great-niece of Harriet Beecher Stowe. Her passionate and dogged effort led to the house's preservation and purchase in 1929, and she personified the Mark Twain Memorial, as it was called, for more than two decades.

None other than Clara Clemens Gabrilowitsch, second from left in front of the house's porch, and her husband, Ossip, third from left, came to town soon after the house's rescue to raise funds. As an accomplished concert singer, she performed with her pianist husband, the conductor of the Detroit Symphony. On the right, in a light dress, is the triumphant Day.

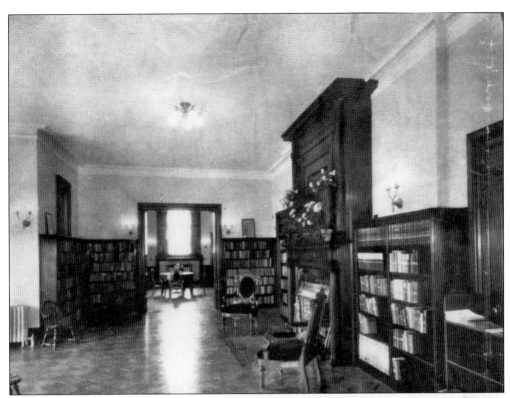

The Hartford Public Library was the first-floor tenant of the Mark Twain House for many years, celebrating its connection with the former author. The mantel and chimneypiece shown here is a 1903 replacement; the old library chimneypiece had left with the Clemenses and was installed in the author's Redding home, which burned in 1923.

In 1955, a visitor touring the library informed his guide that the chimneypiece had not been destroyed in the fire but had previously been removed and was reposing in a barn in Redding, in pieces. A trustee rushed to Redding, and sure enough, there it was, "amid the hay and harnesses," as one writer put it. The visitor's children had their photograph taken with the precious Clemens relics.

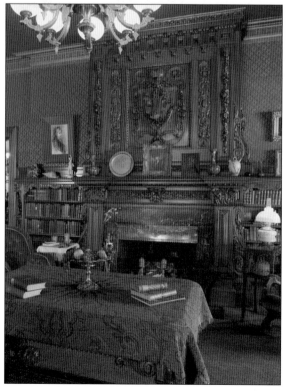

The chimneypiece was returned to Hartford and cleaned, restored, and repaired; here, a craftsman works on a garland of fruit that borders the commingled coats of arms of the Mitchells and Inneses, the families who owned the castle from which the great oak carving had come. The chimneypiece was reinstalled in the Hartford house in 1958.

Once it was in place, one would never know that the dominating feature of the room, which the Clemenses had bought in Scotland in 1874, had ever been anywhere else. Also restored was the pierced brass motto from Ralph Waldo Emerson, chosen by Livy: "The ornament of a house is the friends who frequent it."

Other items made it back to the house. A floor-to-ceiling mirror originally in the drawing room had been sold in an auction the Clemenses held when they sold the house; it made its way to a Hartford upholstery company, whose owner returned it in 1959. The Clemens girls had long ago used it check the positions of their feet during dance lessons.

Clara, who had been in charge of her father's literary legacy since his death, was a tremendous help in the restoration effort during the 1950s. She said that it "really looks like my own former home, the scene of my childhood days." She was urged by one of the driving forces of the restoration, Edith Colgate Salsbury, to mark what she remembered on a chart of the house.

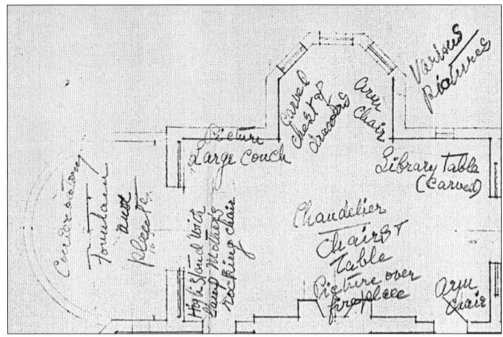

Clara's comments on her chart of the library note "Mother's rocking chair" (see page 102), now back in the house and the "library table (carved)," now, because of the circuitous fate of dispersed artifacts linked to the famous, reposing in a museum in Florida, Missouri, Clemens's birthplace. "Fountain and plants" describes the conservatory then and now.

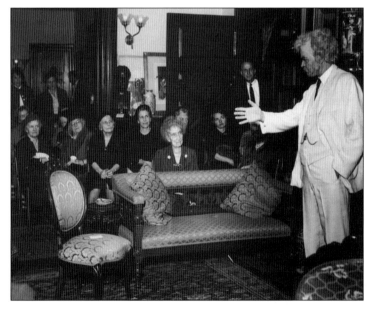

One of the big draws of the restoration period was Hal Holbrook, who first performed to benefit the Mark Twain Memorial in 1956 and in February 2015 was still doing it, appearing at Hartford's Bushnell Performing Arts Center on his 90th birthday. Here, in 1960, he performs in the library to an appreciative audience including, seated second from left, Katharine Day in a fur collar.

The restoration work included a careful removal of decades of wall coverings and paint, and the drawing room (shown here) revealed the Associated Artists' stenciling in a paisley pattern. The original work on plaster was, for the most part, covered by canvas that could be removed if restoration ideas changed in the future; then, new paint and stenciling was laid onto the canvas.

Detective work—and a helpful 1903 preservation of a wallpaper sample in New York's Cooper Hewitt Museum—established that the dining room was most likely decorated with a red, gold, and brown paper made to imitate embossed leather. This paper, with its lilies and leaves, was used in the restoration of the room.

During the exterior restoration and repair, jigsaw work on the porch replicated the style that led Clemens to describe his house once to a Viennese friend as part cuckoo clock. A massive fire escape was removed and replaced with an interior stair that obscured two bathrooms but complied with safety codes.

Underneath black-and-white-painted brick were found the original colors, vermilion and black in decorative patterns. Clemens himself supposedly wrote the poem printed in an insurance company's publication in 1887 that describes his own house as "The House That Mark Built": "These are the bricks of various hue / And shape and position, straight and askew / With the nooks and angles and gables too."

Modern Hartford has changed considerably, and the modern Mark Twain House & Museum reaches out to the community with a panoply of events and programs. In an in-house skit about baseball in Mark Twain's era, children from a local theater group sit on the porch almost exactly where Susy, Clara, and Jean sat 123 years earlier (page 89).

Samuel and Livy Clemens still survey their restored Hartford home, facing each other over an expanse of hall and drawing room. The author and husband is represented in a sculpture by his protégé Karl Gerhardt; the wife and presiding genius is represented in a bust her parents commissioned, brought to Hartford from Elmira. (Photograph by John Groo.)

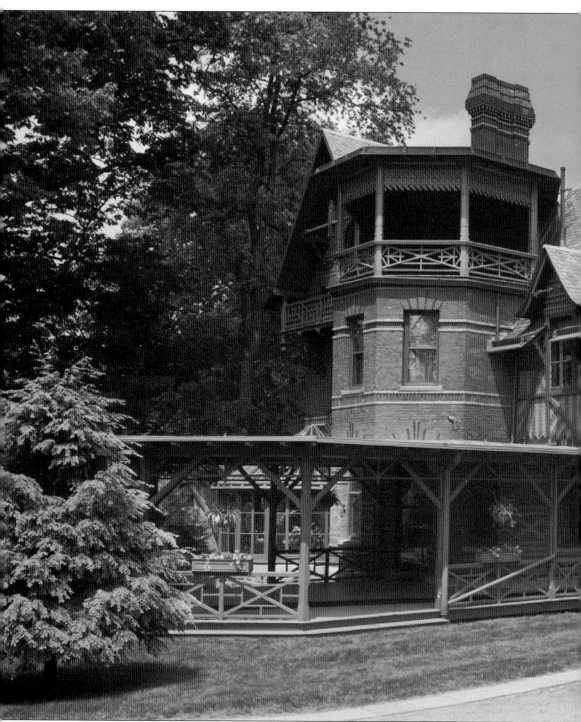

In the changed Hartford of today, Mark Twain's house no longer sits in semirural splendor but on a busy city avenue. Its beauty comes not only from its meticulous restoration but also from its inspiration to generations of city schoolchildren who visit it, from the stories of the family told by deeply knowledgeable guides, and in the glorious events and writing classes that make it a

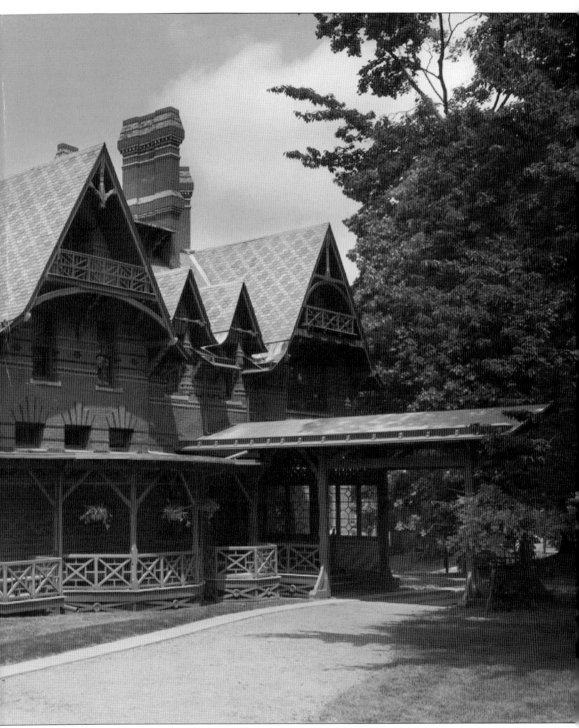

hive of creative activity for Hartford. Clara described their parting from the house in 1891: "We passed from room to room with leaden hearts, looked back and lingered—lingered. An inner voice whispered we should never return—and we never did." But for thousands of visitors a year, this house still has, as Clara's father writes, "a heart & a soul & eyes to see us with."

DISCOVER THOUSANDS OF LOCAL HISTORY BOOKS FEATURING MILLIONS OF VINTAGE IMAGES

Arcadia Publishing, the leading local history publisher in the United States, is committed to making history accessible and meaningful through publishing books that celebrate and preserve the heritage of America's people and places.

Find more books like this at
www.arcadiapublishing.com

Search for your hometown history, your old stomping grounds, and even your favorite sports team.

Consistent with our mission to preserve history on a local level, this book was printed in South Carolina on American-made paper and manufactured entirely in the United States. Products carrying the accredited Forest Stewardship Council (FSC) label are printed on 100 percent FSC-certified paper.

MADE IN THE USA